Living with His Camera

LIVING WITH HIS CAMERA

JANE GALLOP · PHOTOGRAPHY BY DICK BLAU

DUKE UNIVERSITY PRESS *Durham and London 2003*

©2003 Duke University Press

All rights reserved

Typeset in Minion Printed in China

Library of Congress Cataloging-in-Publication Data

appear on the last printed page of this book.

For Marianne Hirsch and Gary Weissman,
like family,
who showed me the path
from my work to Dick's and back

Contents

Living with His Camera 1

Cohabitation: A Methodological Preface 12

1. Observations of a Photographed Mother 19

2. The Unhappy Woman and the Empty Chair 55

3. The Photographer's Desire 91

4. Art in the Family 130

Notes 183

Index 195

Living with His Camera

Living with His Camera

The photograph on the cover is of me; it was taken by Dick Blau the day we started living together. In June 1983, having known each other for four years, we rented an apartment and moved in together. This empty room would be my study, but first it would be Anna's room when she arrived a few weeks later to stay with us for her summer vacation. (Anna is Dick's daughter, twelve that summer; in three years this would become the baby's room.) We'd painted the apartment the day before, slept there for the first time the night before; it's morning, and—for some reason I don't remember—I've set to work before getting dressed. I'm bare; the room is bare; everything seems new, not yet begun, prefatory.

Dick took my picture because that's what he does. He had been making photographs for fifteen years by the time he took this picture. The central body of his work was then (and still is now) pictures he takes in the course of daily life, especially at home, of the people who live with him and of visiting friends and family. Going about his life, he would "see" a photo, pick up his camera, and take it. Living with Dick means living with his camera. The photo on the cover was taken the day I began to live with his camera. (Of course even before we lived together, it had been part of our

relationship. Before I was living with it, I was going out with his camera—he'd bring it along on dates.)

The picture implies that Dick was watching while I worked. Although in the instant he took this photo, that was literally true, it is a deceptive, misrepresentative truth. It leaves out the fact that he was busy cleaning in another room, looked up, "saw" a photo in what I was doing, put down his work, came and took the picture, and then returned to work.

All photographs may be deceptive in this way. In fact, according to Susan Sontag, this misrepresentation might be intrinsic to photography: "A set of photographs that freezes moments in a life . . . contradicts [life's] form, which is a process, a flow in time. The photographed world stands in [an] . . . essentially inaccurate relation to the real world. . . . Life is not about significant details, illuminated a flash, fixed forever. Photographs are."[1]

Because this photograph represents a moment where I am cleaning house (just like a woman) and Dick is a spectator, deriving aesthetic surplus value from my work (just like a man), I want to stress the disjuncture between this picturesque moment and the ongoing reality it does and does not represent. For example, he did more of the painting of the apartment and more of the cleaning than I did, and he did most of the packing of both the apartments where we had lived separately before we moved in together. In all fairness I must say, right here at the outset of this book, that Dick has always done the lion's share of the domestic labor in our household. I must say this because the photographs, gender stereotypes, your preconceptions, and my narrative voice will all nonetheless lead you to conclude otherwise.

I put this picture on the cover because of the way—with its woman, its walls, its implements of household labor—it portrays domestic life.

Domestic life is about dailiness, household work, but it's also about the body, intimacy, and nakedness. Living with a camera means that both the domestic and the intimate are available to the camera's gaze.

Here I am holding a broom, with mop and pail romantically lit, beckoning in the background. The alluring mop recalls the genre of hokey television commercials that romanticize the housewife's work (she does it because it gratifies her; her desire is for a clean house). My nakedness suggests a sexual fantasy underpinning the commercials. The fantasy housewife keeps the house clean *and* her flesh accessible to the man's every whim (like Marabel Morgan's goofy 1970s *Total Woman*, meeting hubby at the door robed only in Saran Wrap). The fantasy housewife here has no face; her head, located at crotch level, is a mass of dark hair; her head has become pubic.

(As I begin to read the photo, the suggestions in its rendering of my body, I find myself losing the pronoun of my subjectivity, speaking of that body not as "I" but as "her." Contemplating this body without a face, I find that it cannot speak; I can only speak about it.)

I put this photo on the cover because it can typify the idea of "living with his camera," because it presents a typical, even stereotypical, image of the domestic woman. But this picture is in fact also completely atypical. It's not that I rarely sweep in the nude, but in fact I seldom sweep at all. The photo catches me in an atypical moment, doing an atypical thing, and produces a compelling fantasy of me as a domestic woman. It is in the play between such fantasies and such realities that I'd like to locate this book—in the tension between the way this photograph is and isn't representative.

The cover photo is as atypical of Dick as it is of me. It was shot in color,

3

while Dick is very much a black-and-white photographer. All the pictures *in* this book are black-and-white photos. While atypical of Dick's work, color absolutely typifies contemporary family photography. At approximately the same time Dick began making black-and-white art photographs of his family, the family snapshot went color. Just as the image brings me closer to a stereotypical housewife, color brings the photo closer to conventional family photography.

In fact, at the moment we moved in together Dick was supplementing his income by shooting weddings—which is why he happened to have color film in his camera that morning. Ironically, he had been driven to wedding photography by the economic effects of his divorce. And, while he had the strongest resistance to our getting married, Dick really liked doing weddings. He liked the mix of reality and theater.

Shooting weddings had gotten him interested in color photography, hence this picture. This image of me as a housewife was taken at the moment we began "our life together," on film left over from someone else's wedding. Since Dick and I never got married, this is the closest thing I've got to a wedding photograph.

But this picture lays bare what weddings are supposed to cover. This is a morning-after photo: the radiant gown has been stripped off and packed away, and the new bride discovers that it is not before but after marrying Prince Charming that she becomes Cinderella.

Like all wedding photos, the picture on the cover is a document in our domestic history: it records the moment Dick and I set up house together. But it is *also, nonetheless,* a parody that borrows our real life to tell another story, a clichéd story. Both true *and* misleading, this photo becomes truly

4

representative in its portrayal of a tension about conventional domestic life, its gender roles, petty dramas, and deluded fantasies, all of which we in fact negotiate in our life together. While the whole story, our ongoing relation, differs from the stereotypes of domestic life—is actually and explicitly an attempt to differ—so many are the moments when we discover to our horror and amusement that we "look like" the worst conjugal stereotypes.

I put this photo on the cover for its resonance with the book's title. Like the image, the title plays with stock representations of domestic life. Like the image, the title is both serious and a joke.

The title refers of course to the fact that I am "living with" Dick. Together we have, over the years, made a home and a family. But we have also nonetheless quite stubbornly refused to get married. Our resistance to marriage is a resistance to the "happy ending," which closes down, idealizes, or denies the endless negotiation of selves and hopes, desires and histories. Marriage is like still photography: it freezes a moment and makes that moment look like eternity.

And yet not getting married in no way suffices to avoid the stock scenes of domestic life. The fact that we aren't married means something; it matters to us (as it does to those few it shocks). But the fact that it means something also seems silly. After all these years and in the face of our daily life raising children together, it seems a petty technicality.

Our ambiguous, not-quite-married status affords the perspective for jokes. Not literally married, we are continually figuring marriage, playing marriage, acting married, representing marriage. Not literally married, there is a teeny gap between representation and reality, a gap that allows space for jokes, as well as for interpretation.

Central to comedy, a boon to farce, marriage is pay dirt for jokes. ("Take my wife. . . . Please!") And trying to pretend that one's relationship differs from the farcical stock of conventional marriage is the surest way to become the butt of the joke. Not to recognize one's place in a marriage farce is precisely to be the joke rather than to get it.

While the first meaning of "living with his camera" asserts our status as not married (just "living together"), that meaning is shadowed by a second. The phrase "living with" is frequently used to mean habituation to something unpleasant and threatening that must somehow be tolerated because it isn't going to go away (as in "living with diabetes"). This sort of habituation is the joke perspective on romantic cohabitation, the pratfall from romance into realism. Marriage is so ripe for jokes because it begins in idealism and descends all too soon into hyperrealism.

The resentment carried by this second sense of the title makes me sound like a typical wife, complaining about her husband and his *thing*. That "thing" could be his hobby, his obsession, his tool, his machine, his technology, his toy—all found in wives' stock complaints about husbands. This discourse invokes male stereotypes and views men as little boys. We hear a mother's knowing voice, but the tone is not one of tenderness; instead, we hear a wife's resentment that the "boy" isn't the man she thought she'd married.

While the "his" in my title refers of course to Dick, it is meant also to be generic, carrying this sense of the camera as a thing belonging to a male. Here is a particularly devastating account of the camera as male thing:

> The camera as phallus is, at most, a flimsy variant of the inescapable metaphor that everyone unselfconsciously employs. However hazy our

awareness of this fantasy, it is named without subtlety whenever we talk about "loading" and "aiming" a camera, about "shooting" a film. . . . The camera/gun does not kill, so the ominous metaphor seems to be all bluff—like a man's fantasy of having a gun, knife, or tool between his legs.[2]

The male "thing," I've been trying to avoid saying, is of course the phallus, which Sontag here names. Sontag's view is withering: the phallus here is *at most* "flimsy." Sontag is no housewife (she is arguably the most influential American woman intellectual of her generation), but her tone here is remarkably consonant with wifely complaints belittling men and their things.

Contemptuous of men and their fantasies, she reduces the brandished weapon to boys-playing-with-toys. But the famous critic, like a shrewish wife, is at once reductive *and* accusatory. Not only does she belittle male fantasies ("all bluff"), but she also, in the very next sentence, makes it clear that, while childish, male fantasies are far from innocent: "The camera/gun does not kill, so the ominous metaphor seems to be all bluff—like a man's fantasy of having a gun, knife, or tool between his legs. Still, there is something predatory in the act of taking a picture." While the phallic fantasy with which the first sentence ends makes men look foolish indeed, the next sentence turns the first one around, suggesting that the "ominous metaphor" only *seems* but is not in fact "all bluff." The camera is *still*, in a way, a weapon. ("Still" is the word for it. Again and again Sontag refers to "still photography," which freezes movement and takes the life out of life. The camera literally "stills" life.)

With its generic male possessive, my title calls to mind the classic

complaints about men and their silly, dangerous things. The title alludes not only to generations of wifely complaint but also, as Sontag here illustrates, to a formal critical tradition. Or rather, two critical traditions: the traditional critique of masculinity and the traditional critique of photography. "His camera" is damned both as "his" and as "camera."

Sontag is devastating, but in order to achieve that rhetorical effect she cannot tell us about her love for photography. Perhaps that is why her tone sounds like high conjugal complaint. To pull off her sardonic effect, the wife cannot mention the love and idealism that led to her marriage in the first place.

My title likewise affords me the pleasure of wit and superiority along with the support of a long rhetorical tradition. But, however rhetorically compelling, the joke is but the *second* meaning of the title. The primary meaning is still straight. I want to try and talk about lived experience with Dick's photography, to speak about the place of his camera in our daily life.

If Sontag sounds the note of arch humor (living with *his* camera), I find the tone of dailiness (*living* with his camera) in Kathryn Harrison's 1993 novel *Exposure*:

> Edgar Rogers wore the Leica all the time, taking it off only at night, when he put it on the little table by his bed; he put it back around his neck as soon as he woke up, over his pajama top. . . . At breakfast, he'd pick the Leica up, still chewing; he'd look through the dark lens, change the aperture, the focus, put it down, take another bite of toast.[3]

Here is the language of home life: bed, pajama, breakfast, toast. But among the cozy nouns, we encounter another set of nouns, a hard, technical

lexicon: lens, aperture, focus, Leica. Technology in the bedroom, technology at the breakfast table. The image here is not of photography, not of taking pictures, but literally of the camera. I recognize this image from our home life, perhaps first of all because of the camera—not just any camera, but "the Leica."

The Leica is a camera for bed and breakfast, pajamas and toast. As long as I've known Dick, there's been a Leica around. He talks about how light it is, how compact and how quiet. Easy to carry, easy to hold, not too clunky, not too intrusive, small enough to take on dates or to the playground with the kids, the Leica is a camera you can live with.

Three-quarters of a century ago, Leica brought out the 35-millimeter camera and inspired a new kind of photography—a photography not of the studio, but of the street:

> After I bought the Leica in 1928 I went completely crazy. I could finally express all that had been dormant; with this machine I could photograph everything I wanted.—André Kertesz

> I had just discovered the Leica. It became the extension of my eye, and I have never been separated from it since I found it. I prowled the streets all day, feeling very strung-up and ready to pounce.—Henri Cartier-Bresson

The Leica was a camera that could go anywhere; it could photograph "everything." Whatever camera he actually uses, Dick's photography is in this Leica tradition. The camera unobtrusive enough to go anywhere, to become an extension of the photographer's body, is unobtrusive enough to

live with. The camera that was perfect for the streets is also perfect for domestic photography.

The Leica made Cartier-Bresson an animal of the streets. "Prowling" and "pouncing," he's the very image of Sontag's predator. I left Sontag above because I wanted to get away from her vision of the predatory male photographer, but I seem to have found my way back to it. And I haven't even dealt with the fact that Harrison's *Exposure*—which I wanted to use here solely for its naturalistic rendering of life with camera—is actually a novel about a predatory domestic photographer.

I can't seem to leave Sontag's accusations behind. Or I don't seem to want to. It's not that I think Dick's relation to me and the kids is predatory. I don't; it isn't. Dick is no Edgar Rogers, who risks his daughter's health for the sake of his beautiful photographs of her.

Just as it is inevitable that our domestic life must repeatedly reckon with the most awful conjugal clichés, so in telling of life with a photographer I have to tangle with Sontag's vision of predatory male photography. I cannot banish it with any simple gesture; it must return again and again.

Just as in these days where domestic abuse and predatory sexuality get so much attention, it never is enough to make the plea that *this* man is a good man; just so it will never be enough to assert that *this* photographer is not a pig.

He really isn't. I wish you could just take my word for it. But since you won't, since you can't, I'll have to keep grappling with Sontag, with the dark side of *Exposure*, with the question of predatory photography. I can't seem to get rid of it, so I'll just have to live with it. At least, like our unwitting descent into conjugal cliché, it makes for good jokes.

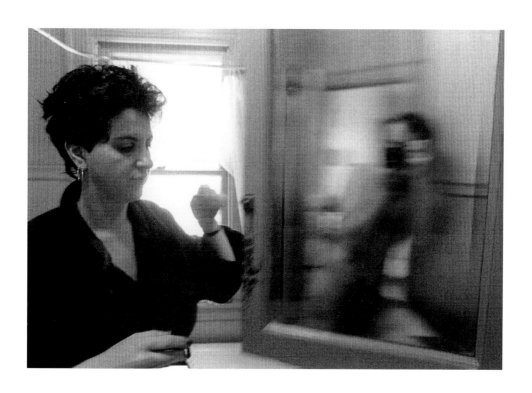

Cohabitation: A Methodological Preface

Although this is a book about Dick Blau's photographs, it does not represent the whole range of his work but rather explores a series of intersections. Each of the four chapters stages an encounter between a small set of Blau's pictures and an influential book concerned with photography. *Living with His Camera* is meant to be not only an essay on Blau's photography but also, perhaps more so, a critical reading of four books.

Chapter 1 considers Roland Barthes's *La Chambre claire: Note sur la photographie (Camera Lucida: Reflections on Photography)*. Barthes (1915–1980) is quite possibly the most important French literary and cultural critic of the twentieth century. His founding role in cultural studies *(Mythologies)*, structuralism *(S/Z)*, and poststructuralism *(The Pleasure of the Text)* gave him enormous influence on criticism internationally. From beginning to end, Barthes's work is an extraordinary hybrid of daring theoretical insight and refined literary attention to the grain of writing. Published in 1980, *Camera Lucida* was the last book Barthes wrote. It culminates his lifelong attempt to produce theory that honors the singular, by giving us a formulation of photography that is at once convincingly general and movingly personal.

Barthes has been a major influence in my intellectual formation, both as a

theorist and as a writer. *Camera Lucida* models for me the sort of writing I am trying to do, a writing that combines intellectual work with self-reflection, theory with memoir. As the model that authorizes my present effort, *Camera Lucida* is the book I begin with.

The second chapter turns to what is arguably the most influential book about photography ever written, Susan Sontag's *On Photography*. An American public intellectual and cultural critic of wide range *(Against Interpretation; Styles of Radical Will; Illness as Metaphor)*, Sontag (born 1933) has had a lifelong interest in photography. First published in 1977, *On Photography* continues to be the text most often cited by essayists and academics writing about the topic. I turn to Sontag's book not only because of its explicit influence, but also because it articulates what remains the dominant view of photography today—a view casually held by many who have never read Sontag's book—that sees photography and the photographer as uncaring and detached, contributing to the increasing loss of reality and authenticity in modern life.

Barthes and Sontag, while their style and tone could not be more different, share not only a mutual admiration and respect but also a view of photography very much influenced by their formation as literary intellectuals. If I find Barthes and Sontag to be good companions as I attempt to write about photography, it is undoubtedly because, like me, they confront photography as people more accustomed to thinking about books and words.

In any theoretical or cultural studies work on photography today, Sontag's and Barthes's books are touchstones. These are the two books most often cited; they are obvious or natural choices for the present study. The other two books I have chosen are less obvious, canonical, or authoritative;

the books for my last two chapters are not central to photography theory—strictly speaking, they might not even belong to the genre. I have found them highly suggestive, but more than the first two books, the second pair are likely to need an introduction. Both authors are quite well known, but not particularly for their work on photography.

The book for the third chapter—Kathryn Harrison's *Exposure*—is not a text of theory but a novel. I find it nonetheless to be a substantial contribution to understanding photography, and so I read it as theory. Published in 1993, *Exposure* is a novel about a photographer who made celebrated art using his daugher as a model. The view of photography and the photographer in this novel is very much in keeping with Sontag's view, but as a novel it allows us to explore the personal, familial, and psychological dimensions of photography that Sontag's essay only gestures toward.

Harrison (born 1960) is a critically acclaimed novelist best known for her scandalous 1997 memoir *The Kiss*. Like some of her novels *(Thicker than Water)*, the memoir surveys the dangerous edges of the father-daughter relation. *Exposure* concerns similar sorts of psychological and familial dynamics but locates them within a photographic relation. Harrison's novelistic and familial viewpoint moves our theorizing of photography in more literary and more psychological directions, yet her well-researched grounding in the history of photography makes this novel an invaluable companion for exploring the poignant and fraught place where the camera would capture the child.

The book for the final chapter is Pierre Bourdieu's *Un Art moyen: Essai sur les usages sociaux de la photographie (Photography: A Middle-Brow Art)*. The most important French sociologist since Emile Durkheim, Bourdieu (1930–

2001) has had extensive international influence on cultural theory and criticism in the last few decades. Despite this influence, his book on photography is not well known. Originally published in 1965, it was not translated into English until 1990 and has since gone in and out of print. Bourdieu's study of photography was his most detailed study of an art form, and it forms the basis for his later, better-known ideas about painting, literature, taste, and culture in general *(La Distinction ; Les Règles de l'art)*.

In the early 1960s Bourdieu directed a team of sociologists surveying the uses of and attitudes toward photography in France, looking at the entire range of photography from high art to family snapshots, including journalism and advertising. On the basis of this carefully collected material, *Un Art moyen* makes broad and stunning theoretical claims about photography, society, art, and the family. This look at photography from a sociological point of view allows us yet another way to think about the relation between art and the family, one that focuses not so much on the psychological dynamics of Harrison's perspective but on family as social group and institution.

Writing this book, I found myself faced with a difficulty I had never encountered before. Each chapter has not one but two centers; each is both a reading of a book and a reading of Blau's photographs. The double focus of the chapters has turned out to be the source of considerable worry.

I often found myself worried either that I wouldn't get (back) to the photos or that I wouldn't get (back) to the book under consideration. I feared that one of the two objects of study would take over and subordinate the other.

In retrospect, I think that everything else I've ever written has had a single focus. There has always been a primary object of study, a primary text, and although of course I would talk about more than one text, the other texts were secondary, ways of amplifying my study of the primary text.

With the present book, when my writing began to flow I would find I had returned to my more usual procedure, following the contours of a single object of study. But if I let myself do that, I would either turn the photos into mere illustrations of the theory I was reading or I would turn the books into mere glosses of the photographs.

What I found I had to do to protect against that danger was to write very slowly, at something like half my usual pace. If I wrote slowly, going over and over my paragraphs, backing up and adding material, I could find a way to keep both of my objects with me.

After I had drafted the second chapter, I had occasion to present it at an academic conference. I was asked if I considered this a reading of Sontag's book, since there were aspects of the book I do not discuss. I take a particular angle of entry into the book and follow one network (the critique of photographic detachment, of the touristic gaze) while ignoring other insights of Sontag's dense meditation. Although I sincerely hope chapter 2 will contribute to the understanding of *On Photography*, I know that it (like all the other chapters) is a peculiar sort of reading, not what I would have done had I taken Sontag's book as the single, primary focus of my writing.

The present book likewise represents only a small subset of Blau's photographic production. Blau has made hundreds of noteworthy photographs over the last thirty years; the present book discusses only a couple dozen of those and touches on only a few of the major themes—whole

series are missing. Had I set out to write a monograph on Blau's photography, I would have chosen a sampling more representative of the whole.

The subject of each chapter is in fact neither the book it examines nor the photographs it discusses; the subject of each chapter is the intersection of book and photos. Each of the books was chosen because its take on photography resonates with Blau's work and vice versa.

I chose the four books, however, not only for what they had to say about photography but also for who wrote them. Barthes was the author closest to me; I chose to begin with him in order to connect the present book with my previous work. Because of their importance in my academic discipline, Sontag and Bourdieu are figures I wanted to reckon with. And finally, like all the other books, I chose *Exposure* not only for its insights on photography but also because of its author. The controversy surrounding Harrison's memoir made her—like Barthes, Sontag, and Bourdieu—a figure that allows me to visit major debates in contemporary literary theory.

In various ways, the four books can be said to represent my interests, knowledge, expertise—my professional life. The photos, on the other hand, can represent my domestic life. Thinking back on my anxiety that either book or photos would overwhelm and dominate the other, it looks like a version of a longtime worry of mine. The peculiar balancing act of writing this book is not unlike my attempt to balance work and home, trying to hold on to both, always afraid of losing one to the other.

The double center of this book may be particularly apt for its topic. In writing the book my problem has been trying to keep the center double, not having one focus become primary and the other become subordinate to it.

I'd like to call this peculiar writing problem "cohabitation." Cohabitation and not marriage: the latter is the figure for merger, union, two melting into one. While I admit my attraction to that grand old synthesis, cohabitation is a better figure for the irreducible doubleness of this book. Although worrying about keeping the center double is new to my writing, I recognize it as the long-term project of cohabitation.

1 · Observations of a Photographed Mother

Photography, according to Roland Barthes, can be considered from three possible points of view. First, of course, is the photographer's point of view. Near the beginning of *Camera Lucida*, Barthes's book on photography, he tells us that he "could not join the troupe of those (the majority) who deal with Photography-according-to-the-Photographer" because he does not take pictures.[1] While for many this would not in fact pose a major obstacle to adopting such a perspective, Barthes is committed to grounding his study in his own experience. Thus he restricts himself to the two remaining standpoints: that of the person photographed and that of the person who looks at photos.

Barthes's next chapter discusses how he feels about pictures of himself and how he feels when being photographed. Entitled "He Who Is Photographed," it is the book's longest chapter. The following chapter, "The *Spectator*," turns to the third perspective. And the rest of the book, forty-two more chapters, stays with that third perspective.

I want here to pick up the position *Camera Lucida* initially assumes and then drops. If, according to Barthes, photography is most often treated from the photographer's point of view, almost all the rest of the writing on pho-

tography is surely from the perspective of what he calls the "spectator," whether the latter be art historian, critic, or amateur. Formal discourse on photography is rarely from the standpoint of the photographed subject.

Although Barthes does speak as "He Who Is Photographed," this standpoint has a peculiar, somewhat uncanny status in *Camera Lucida*. When he introduces the three perspectives, Barthes gives them Latin names: *Operator, spectrum,* and *spectator* (9). While he goes on to use the terms *operator* and *spectator* throughout the book, after first naming it he never again uses the term *spectrum*.

Explaining why he chooses the word *spectrum*, Barthes says that not only does it connect etymologically to "spectacle," but it also connects to "specter," ghost. While the *spectrum*, "He Who Is Photographed," seems to be left behind as the book progresses, this intentionally ghostly figure might continue to haunt *Camera Lucida*.

Barthes's book on photography is in fact haunted by a number of ghosts—most notably an old, faded photograph that we cannot see but whose presence nonetheless pervades the text. Halfway through the book, Barthes definitively if subjectively locates the essence of photography in that one picture: "Something like an essence of the Photograph floated in this particular picture. I therefore decided to 'derive' all Photography from the only photograph which assuredly existed for me" (73). This singular photo is a picture of Barthes's mother made by an anonymous provincial photographer. Given the status of this picture, we might say that in *Camera Lucida* the exemplary *operator* is anonymous, the *spectator* is Roland Barthes, and the *spectrum*, the quintessential photographed subject, is the mother.

Barthes would resist my last phrase—not "the mother," but rather "my

mother," he would say. And he does say that quite emphatically in the text: "[Nor] would I reduce my mother to the Mother. . . . In the Mother, there was a radiant, irreducible core: my mother. . . . To the Mother-as-Good, she had added that grace of being an individual soul" (74–75). If I don't here respect Barthes's otherwise quite moving insistence on his mother's singularity, it is because in examining the photographed subject in *Camera Lucida* I am struck by its similarity to the position of the mother or, as Barthes would say, "the Mother."

In the only chapter where Barthes inhabits the position of "He Who Is Photographed," he writes, "the Photograph represents that very subtle moment when . . . I am neither subject nor object but a subject who feels he is becoming an object" (14). In the course of the book Barthes abandons this position and attaches it definitively to his mother. Upon rereading Barthes's description of his experience of being photographed, I notice that it might also describe a mother's experience ("I am a subject who feels she is becoming an object").

Although *Camera Lucida* never directly makes this connection, the mother does appear, if ever so faintly, in Barthes's experience as photographed subject. In "He Who Is Photographed," Barthes describes his thoughts while "posing in front of the lens": "An image—my image—is going to be born: will I give birth to an antipathetic individual or to a 'good guy'?"[2]

I provide my own translation for Barthes's French here because something has been lost in the published English translation: "An image—my image—will be generated: will I be born from an antipathetic individual or a 'good sort'?" (11). Finding a birth image in Barthes's description of having

his picture taken, the translator makes Barthes himself the baby, whereas Barthes in fact imagines himself as giving birth. The French here is idiomatic and difficult to translate ("va-t-on m'accoucher d'un individu antipathique ou d'un 'type bien'?"). Whatever the best English equivalent, it is clear that by using a verb that means giving birth (*accoucher*) Barthes places his first-person pronoun in the position of the birthing body. Speaking as the photographed subject, as the subject who "feels he is becoming an object," Barthes for a moment imagines himself in the position of the mother.

It may be worth noting that in the specific French expression Barthes uses the birthing woman is not the subject of the verb but its object. In his French phrasing, the verb's subject is an impersonal, unnamed figure (*on* ["one"]) who aids in the delivery, who brings forth the child from the birthing body. This grammatical construction suggests how Barthes likens posing for a camera to giving birth. Whereas "giving birth" could suggest maternal activity, Barthes chooses a phrase that makes the maternal body a passive object. The unnamed obstetrical agent is the *operator* who brings forth an image from Barthes's passive body.

Perhaps it is this sense of himself in the position of the mother, the passive mother, that makes Barthes abandon the perspective of the photographed subject. And perhaps it is the sense of the position's maternity that makes him pass it on to his mother as the book progresses.

I want here to return to this perspective, which Barthes initially explores and then leaves behind. I want to pick it up as the mother's perspective and try to inhabit it for a while. I'd like to write about photography from the standpoint of the photographed mother.

I begin with a reading of *Camera Lucida* because it allows me, before I as-

sume the position of the mother, to show you my professional persona. I begin by speaking as someone with a doctorate in French, a specialization in French critical theory, someone who has often taught and written about works by Barthes. Although I want to try and speak as a photographed mother, here in this book published by a university press I find it easier to begin by speaking as a reader of Roland Barthes.

Although writing a book on photography represents a significant departure from my previous work, I have in fact written on *Camera Lucida* before—the only other time I wrote about photography. I published my earlier reading of *Camera Lucida* in a book with a photograph of a birth on its cover.[3] I did not at the time see any connection between Barthes's book on photography and this birth scene, but now I find the picture uncannily resonant with Barthes's account of the photographed subject .

The photo captures a moment when the mother is passive, still, whereas the obstetrician seems to be actively pulling the baby out with his gloved hand. The mother in this scene might well be wondering what is being brought forth; unlike the doctor, the nurse, the photographer, and the spectator, she cannot see what is emerging.

In this photograph the mother is not only passive; she has no head. In fact everyone in the picture has a head (nurse, baby, doctor) except the mother. While her head is missing, there is a head attached to her body, her son's. It is as if her head were replaced by his. If the photographed mother here is "a subject becoming an object," her son might be an object becoming a subject. Does she lose her subjectivity as he gains his?

This photo was taken by Dick Blau, who made all the pictures in the present book and who fathered that little emergent head. This is a picture of

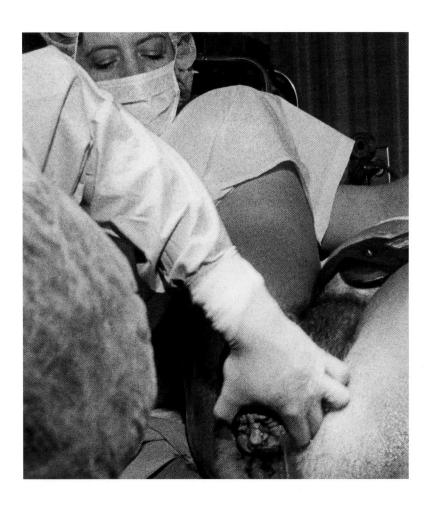

me giving birth to my first child. While I put this image on the cover of a 1987 collection of my writings and spoke about the photograph in the book's preface, I did not mention that I was the mother in the picture.

I did not write as the photographed subject; I wrote as the spectator, observing the image's configurations and offering interpretations of what I saw. If I have an urge here in the present text to accuse Barthes of some sort of cowardice in preferring to speak as spectator rather than photographed subject, I need to remember that I too found the position of spectator much more comfortable.

In 1987 I wrote: "I chose a photograph that shows the head in the midst of the body. . . . the female genitals are 'normally considered to be at the antipodes of culture.' I wanted to represent thinking there, to undo that opposition. . . . It was feared that [because of the cover photograph] people would think it a book about obstetrics rather than a book of theory. In thinking about [this], I came to see the mind-body split as exemplified in an opposition between philosophers and mothers."[4]

At the time, I read the photo as a moment of transcending the mind-body split because it represents a head not in polar opposition to but "in the midst of" the maternal body. Looking back at it now I see, however, that my writing about the photo might itself be another example of the split between philosophers and mothers. Writing an academic book of theory, I split off from the mother in the picture and philosophized about her image in the third person.

My inability to speak as that photographed mother reenacts the absence of the mother's head in the photograph. Wherever this mother thinks and talks, it is somewhere outside this scene of giving birth, a scene that seems to deprive her of subjectivity.[5]

My head is not in this birth photograph. When I think about the photograph, when I talk about it, I do it from somewhere outside the frame. I speak not as the photographed mother but as a head split off from that birthing body.

This split could represent the dilemma of theorizing as a mother. My reading of Barthes suggests that it also could represent the dilemma of theorizing as a photographed subject (and even that the two are interrelated). If I want here to try and speak as a photographed mother, I can see I will have to reckon with this splitting.

In *Camera Lucida*, the photographed mother is characteristically silent. Studying the photograph that for him captures his mother, Barthes tells us: "In this . . . image I saw the goodness which had formed her being. . . . I could not define it better than by this feature . . . that during the whole of our life together, she never made a single 'observation.'"[6] The mother in that book is defined precisely as never doing what the author does—observe and comment. In fact, the very paragraph where Barthes praises his mother for refraining from ever making "observations" begins with the words "I observed," to refer to what he saw when he looked at her in the photograph.[7] He observes; she does not; she is observed.

Barthes's mother, in contradistinction to her son, is an ideal photographic subject: "My mother 'lent' herself to the photograph. . . . She did not struggle with her image, as I do with mine" (67). While Barthes cannot settle into the position of photographic subject, his mother can. Barthes's mother is, it turns out, both an ideal photographic subject and the subject of what he considers to be the quintessential photograph. While *Camera Lucida*'s *spectrum* might begin as "He Who Is Photographed," it ends up as "She Who Is Photographed."[8]

26

Barthes's mother—ideal *spectrum*, subject of the quintessential photograph—never made a single observation. Early in *Camera Lucida*, Barthes begins to speak of being photographed and then changes the subject. If the position of the photographed subject seems to lead to silence, surely it is because it is a position where the subject feels himself becoming an object. Unlike a subject, an object does not speak. I can't help but think that the movement by which "*He* Who Is Photographed" becomes "She" offers yet another example of the classic gendering of subject and object.

This classic gendering comes with the standard Freudian package. *Camera Lucida* has occasion to quote Freud on the Mother (40), and, although Barthes's use of psychoanalysis is typically delicate and unsystematic, the book still jibes with the usual psychoanalytic view of the family, where the subject is the son and the object the mother. And so I find in *Camera Lucida* the predictable but nonetheless troubling scenario by which the man saves his subjectivity, his voice, by palming the risk of becoming an object off onto the mother.

Predictable is indeed the word for it: since I am both a psychoanalytic and a feminist critic, it is all too predictable that I should produce such a reading. If that were all there was to my reading of *Camera Lucida*, it would not be worth doing here. Although I have been disrespectful in reducing Barthes's finely sketched mother to the Mother, I want to stop now and pay my respects to him, to assume my debt to his book and to reveal why I'm talking about it here, at the beginning of my own book on photography.

Camera Lucida, in fact, provides the model for what I'm trying to do in this book. Barthes dared to theorize photography from the quite personal place of his subjectivity. He dared to presume that his subjective experience might count as knowledge for others. As far as I'm concerned, his presump-

tion paid off: writing from an unabashedly personal perspective, he produced what feels to me like knowledge.

My project here is the offspring of Barthes's presumption. It is precisely in homage to *Camera Lucida* that I would like to make a few observations as the photographed mother.[9]

Here's another photograph made by Blau , a decade after the previous one. I suppose I should say that this is a picture of me, but that doesn't feel right. I would be more comfortable saying it's a picture of my belly, which makes it more a picture of something attached to me. I'm at my monthly obstetrical checkup, eight months pregnant with my second child, Ruby.

I take this photo as the very emblem of the mother becoming an object, because of the measuring tape, because of the way we think of numbers as the very measure of "objectivity." Since I've just invoked the feminist critique of the objectification of women (in my reading of *Camera Lucida*), and since I'm talking about being turned into an object, you might think that I'm complaining here about being objectified. So I want to make it clear that I'm not complaining. In fact, I'm bragging.

I like to call this photo "The Prize Watermelon." I imagine the viewer impressed by my belly's size; I imagine it being measured at the county fair: when I show you this photograph, I'm proudly displaying the big belly I grew.

My title for the photograph suggests a relation to my body somehow like a farmer's relation to her prized produce. This is a way of embracing my objectification, not simply becoming an object but rather doubling into subject and object: I am at once the farmer and her watermelon. Putting my "fruitfulness" on display, I am, in short, proud to be a mother.

28

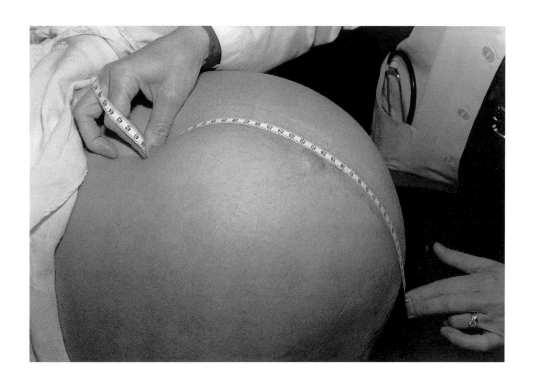

The desire to be a mother (which I would here distinguish from the desire to have a child) might be precisely the wish to become this sort of impressive object: the sort of object that, according to psychoanalysis, our mothers once were for us. While such fantasies are common, they seem better left unspoken. Like Barthes, we prefer to admire the silent mother. To speak one's pleasure in being taken for that magical object called Mother is to display an unsightly narcissism, a narcissism that may be inevitable when the photographed mother speaks.

Narcissism is indeed the word for it. The photographed subject speaks from a position that is literally narcissistic, the position of someone looking at an image of herself. I see now why Barthes might have fled that position. To remain too long, to be too interested in one's own image, is to fall into the trap of Narcissus.

When Barthes does briefly discuss photographs of himself he complains that he never likes them. I imagine this is the most common sort of observation made by the photographed subject: she is most likely to say "I don't like that picture of me." While this is undoubtedly a resistance to objectification (that object is not me), it might also be a strategy to evade Narcissus's fate. We gaze at our image and insistently reject it, refusing to love it.

While this might get us out of the classic position of Narcissus, it leaves us with a common form of vanity. In the chapter "He Who Is Photographed," Barthes writes: "What I want . . . is that my image . . . should always coincide with my (profound) 'self'"(12). We reject our images because we would so love to see our "self";[10] our rejection of our images actually manifests our love for our self.

Barthes's complaint goes on to specify that his image and his self "never

coincide" because the image is "heavy" while his self is "light."[11] Barthes's writing, whatever the topic, quite consistently privileges the light over the heavy, and here as elsewhere the pair of terms carries a range of symbolic and figurative meanings.[12] But when he uses these terms to reject his photographic image, their concrete sense comes to mind.[13] For all its theoretical subtlety, his complaint thus recalls one of the more common themes of vanity—and prompts me to show you a photograph I had originally decided not to include, an otherwise wonderful picture where I don't like how heavy I look.

Some years ago Dick showed this photograph in Greece and came home to report that a psychoanalyst there had found its oedipal resonances disturbing. I liked the idea of shocking a psychoanalyst, but a month or so later as Dick was preparing to exhibit this same picture here in Milwaukee I realized that I too was disturbed by the photo. While I did not mind people knowing that my son and I lie around naked together, I didn't exactly like the idea of neighbors and colleagues seeing my unduly large belly. In this one, no tape measure and no pride; I'm not pregnant.

My feelings about this photograph contrast neatly with my exhibitionist pleasure in "The Prize Watermelon": whereas the tumescent belly fills me with pride, I feel shame in displaying one that is soft and flaccid. In the first picture, my belly sticks up; in the second, my breasts hang down. Such corporeal ups and downs are not without relation to the light and the heavy— the light rises, the heavy sinks. I'm struck by the phallic dimensions of my pride and shame. While my narcissism delights in the image of me as phallic mother, my vanity shrinks from the sight of my fallen flesh.

The photograph that shames me has given us serious and repeated pause.

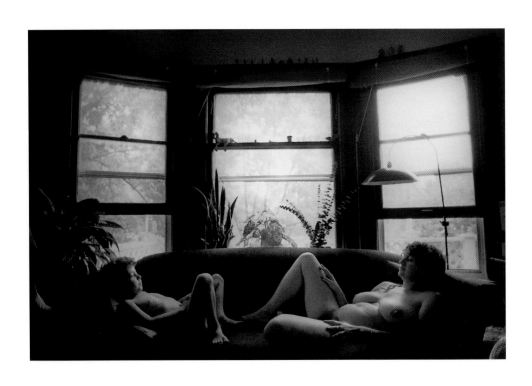

32

More than once, Dick and I found ourselves unable to decide whether to show it—no other photo has caused us this kind of trouble. Throughout our conversations about it, we were not disagreeing with one another; rather we were both of two minds about what to do. The issues were always the same: both of us really like the photograph as statement and composition, but neither of us like how heavy I look in it. A half a dozen years ago when Dick was preparing to exhibit locally, we had several such discussions, going back and forth about what to do. Finally we decided that not to show this unflattering image betrayed the spirit of naked honesty that is one of our family values; so we showed it.

Nevertheless, a few years later we again had the very same discussion about whether or not to include it in an early version of this chapter that I was preparing to publish as an essay.[14] And we seemed to reach a decision not to show it. We reasoned that, whereas an exhibit was ephemeral, once the photo was published it would be in a sense permanently on display—and that seemed like just too much exposure.

What clinched my decision not to publish this picture was imagining my parents' horror at seeing it, at seeing me expose myself that way, in public. The thought of my parents as spectators suggests the peculiar way in which this is a "family photograph." A conventional family photograph is precisely the sort of thing one would send to relatives who live out of town: grandparents would want a photo of their daughter and grandson. They would want it not only to look at it themselves, but to show their friends, to show off. The family photograph conventionally traffics in bragging and pride.

The photo of Max and me on the couch is not the sort of thing grandparents show their friends, and thus not a conventional family photo. But my

vision of my parents' shame reveals that this photograph still functions within the realm of the family. Family photos are in fact all about showing, about taking the privacy of family life and exhibiting it to a public gaze (if only to friends and relatives). The family photo is intended to induce pride by showing a private life for public admiration, but the family photo can also produce shame by exhibiting privates that shouldn't be seen in public.

Although in the end I decided to publish this picture, I'd like to focus on the repeated difficulty of that decision. I take the repetition as a sign that my problem with this photograph—whatever fantasies I might have of bold decisiveness—is just not going to go away. And I wonder if what troubles me about this photo may not, after all, be related to what troubled the psychoanalyst.

When the psychoanalyst saw this picture of a son and a mother lying naked together, he thought about the oedipus complex. The oedipus complex makes the mother's body taboo, prohibits our finding it desirable; the taboo makes us uncomfortable with the mother's nakedness and introduces an element of disgust into our viewing of that body. Perhaps my objection to the picture seems different because I am viewing it from the perspective of the photographed mother; I experience the disgust at that naked body as my own shame. But I'm struck by how the foci of that shame (the large, soft belly and breasts) are the very parts of the body most connoted maternal. Is this body undesirable because, looking too maternal, it elicits the oedipal taboo?

Having decided for a moment to adopt the psychoanalyst's perspective, I find I can see an oedipal specter in *Camera Lucida* as well. While Barthes chooses not to show us the photograph of his mother that he makes central to the book, the chapter devoted to that photo (chapter 28, "The Winter

Garden Photograph") does in fact include a photograph. In place of the picture of his mother, Barthes shows a photo by Nadar, entitled "The Artist's Mother or Wife."[15]

In the very place where we expect to see Barthes's mother, we find this photograph by Nadar. The text explicitly connects this picture to the photo of Barthes's mother: "The unknown photographer of Chennevières-sur-Marne had been the mediator of a truth, as much as Nadar making of his mother (or of his wife—no one knows for certain) one of the loveliest photographs in the world" (70). Barthes here likens the photograph of his mother (made by an "unknown photographer of Chennevières-sur-Marne") to the photograph he shows in its place. Rather than showing us the mother he loves, Barthes introduces into *Camera Lucida* the image of a woman who could be either mother or wife. The inability to make that distinction ("no one knows for sure"), that particular confusion, is the very heart of the oedipal taboo.

Barthes does not show us the picture of his mother because we could not appreciate what he feels. In its place, he puts a photo that equates mother and wife. A few pages later, Barthes tell us that he lived with his mother his whole life (75). I must confess that I respond to this revelation with a slight sense of scandal; I respond very much like the psychoanalyst responded to Max and me on the couch.

Barthes explains, "It is because she was who she was that I lived with her" (75). The phrase "who she was" is meant to refer to what he calls "a being" as opposed to "a Figure (the Mother)." If he insists on this distinction, it is because he expects our reductive response. Able only to see the Mother, the psychoanalytic reading misses *his* mother, the individual being he loved: "To

the Mother-as-Good, she had added that grace of being an individual soul" (75).

Although earlier I chose to make theoretical hay by not respecting Barthes's insistence that we not reduce his mother to the Mother, the photo of Max and me naked makes me want to return to his caution. I can see how an oedipal reading of the couch photo is not only reductive but defensive. For the oedipal reading actually makes this photo less, not more, disturbing. Interpreting the body's excesses as generically maternal tempers the shame I feel about the specificity of that body as my own. If Barthes observes that, beyond the Mother, his mother "had added that grace of being an individual soul," I must admit that to the generic problem of seeing the Mother naked, this photograph adds the shame of my individual body, its particular weight.

Reducing my body to that of the Mother makes it easier for me to bear its heaviness. Barthes, on the other hand, finds the Mother a heavy, crude concept, which his particular mother lightens by adding grace. *Camera Lucida* tells the story of how Barthes looked through and rejected a slew of pictures of his mother until he finally found the one photograph that for him exemplifies both her and photography. Only one of the photographs could coincide with her self, her individual soul. And that was a picture of her as a little girl.

"Starting from her latest image . . . I arrived . . . at the image of a child: I stare intensely at the Sovereign Good of childhood, of the mother, of the mother-as-child" (71). To the Mother, this image adds the grace and lightness of the child. In a way, the picture of Max and me on the couch does the same thing. But rather than the mother-as-child, here we see the mother-

and-child, the child's lightness juxtaposed with the mother's heaviness. As I look at this photo, I find myself sharing Barthes's preference for lightness, experiencing the difference between these two bodies as my lack, thanks perhaps to an aesthetic that reinforces the sense that more is less.

What disturbs me in this spectacle of a mother's body and a child's body naked together is not, *pace* the psychoanalyst, the possibility of incest. When I see those bodies together, framed by the symmetries of the windows, mirroring each other in the similarity of their position, that mirroring makes comparison and contrast inevitable. And I suffer from the comparison.

The insistent symmetry of this photograph creates the expectation of balance between the two bodies and produces an uncomfortable awareness of their difference. My sense of shame at looking so different from Max here perhaps explains why another photograph of the two of us, one where we look strikingly similar, gives me so much pleasure.

In this picture, we are no longer so indecently exposed. While the living room photo is suffused with the light of the outside world, its large windows open, the bathroom's single window is dark and closed. Here in the most private part of the home, nakedness returns to its proper place. Not only because nakedness belongs in the bathroom rather than in the relatively public space of the living room, but because now only the child is naked. Conventional family photos show naked children, not naked parents, and the classic place for the naked child is the bathtub.

The two photos frame us quite differently. While Max and I are together on the black couch, he is alone in the white bath tub. In the bath photo, Max and I are balanced in opposite corners of the frame: my head in the upper left, his in the lower right. The symmetries of this composition do not de-

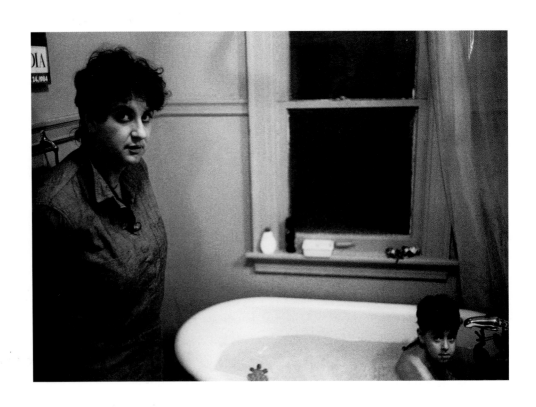

mand equivalence between our two bodies but benefit instead from our relative sizes. Rather than face each other, Max and I face the same way. Our bodies seem not disproportionate but literally in proportion: he reproduces me in miniature.

A friend of mine calls this "the picture where Max and Jane have the same face."[16] While on the couch the bodies shock and their difference unsettles, here in the bathroom it's the faces. Their similarity is positively uncanny.

"In a certain photograph," writes Barthes, "I have my father's sister's 'mug.'"[17] This sentence appears in a chapter called "Lineage," in the middle of a passage that proposes that "the Photograph sometimes makes appear . . . a genetic feature. . . . The Photograph gives . . . the truth of lineage" (103). "Lineage" deals with family as something genetic, bodily, biological. And this animal sense of family echoes in the word Barthes uses for the face he shares with his aunt. "Mug" here translates the French *museau,* which is slang for human face but more commonly and literally means "muzzle" or "snout," the front part of certain animals' heads. Barthes's muzzle reminds me that Dick's title for the picture of Max and me in the bathroom is "The Wolf Family."

This title picks up on the striking family resemblance between Max and me. If, as my friend says, Max and I have the same face, it's not only because we look alike but also because we're making the same face. With two such similar faces making the same expression, the expression itself seems to be a genetic feature, its hostility an instinctual response.

Barthes's resemblance to his father's sister seems likewise to have a behavioral as well as a physical dimension. Many pages before he tells us they have the same face, he mentions this aunt in a parenthesis: "This sister of my father never married, lived with her mother as an old maid" (53). Barthes is

not the only one in his family to live all of his life with his mother.

The resemblance to this aunt, mentioned only in passing, can thus be connected to a central theme of the book—Barthes's relation to his mother. While Barthes does not show us the picture where he looks like his aunt, the chapter that mentions it includes as its only illustration a photograph of Barthes's mother (not the famous "winter garden photograph" but another photograph of her as a little girl [104]).

The comment about looking like his aunt is in fact the only time outside the chapter "He Who Is Photographed" that *Camera Lucida* mentions a photograph of Barthes. Given the spectral and maternal nature of the photographed subject in the volume, it seems worth noting that in this late chapter, Barthes not only fleetingly takes up the position of photographed subject but also shows us his mother, something he seemed unwilling to do.

The photograph of his mother in the chapter "Lineage" is unlike the other illustrations in the book. Every other illustration is what Barthes calls a "public" photograph (60); every other is attributed to a photographer. For this picture and this one only, the book names no photographer; we are told it comes from "the author's collection," that it is "a private photograph."[18] Unlike all the other photographs in the book, the photograph in "Lineage" is a family photograph.

Barthes calls this photograph "The Stock," making reference to the biological, genetic connection between his mother and the old man he calls "her ancestor," with whom she is posed.[19] Earlier in the book, Barthes says he does not want to write about the institution of the family (74); the chapter "Lineage" and its illustration "The Stock" are not about the family as institution but rather a less social version of the family—less culture, more nature.

40

Likewise portraying what Barthes calls "the truth of lineage," Blau's "The Wolf Family" is not a very sociable image of the family.

The idea of a "wolf family" suggests that here the family is not domesticated but rather captured by the photographic gaze. The mother and child look like unwilling subjects of display, resentful of the photograph's trespass into this private space. Our look says, "Get out of here!"

Lying on the couch, mother and son expose too much for a polite family photograph; in the bathroom we are too protective of our privacy. Although our bodies are conventionally decent in this picture, our faces suggest that something was not meant to be seen. If family photography makes the private public and sociable, this picture sees that as an intrusion.

The intrusion begins with the photographer; he is the object of our hostile gaze. While here the photographer is literally the father, the "wolf family" views him as an outsider, not a member of the pack. And Max's striking appearance as my reproduction in miniature even suggests the father's genetic irrelevance.

The father is often the family photographer. Not usually in the pictures, the father-photographer directs, frames, and composes the mother and children. He is the master of the family's image.

As a father photographing his family, Dick has assumed this role. Because his family photographs are his artwork, the role is exacerbated. In taking photographs of his family life intended for exhibition, publication, and even sale, he raises the public-private stakes implicit in all family photography. By making images of his family for public display, Dick places himself between family and world, representing both the family to the world and the intrusion of the world into the family. This is a pretty damn conventional role for a father to play.

All the players in the bath photo—father, mother, child—are in our most traditional places. But in portraying the mother and child's resentment of the father, this is hardly a conventional family picture. With its combination of traditional roles and hostile resistance, "The Wolf Family" could be said to expose the patriarchal relations underpinning polite family photography.

The subjects' hostility may also suggest another equally traditional if not so photogenic dynamic. The father-photographer has entered a space of mother-son intimacy and that intrusion is resented: "Go away so we can be alone together!" Perhaps that psychoanalyst was right to worry about Max and me.

If I've come close to concurring with the psychoanalyst, it may be because up until now I haven't been speaking from my experience as subject; I've been reading this photograph like a spectator. I see again how easy it is to slip into that position. Let me now speak as the photographed mother.

While as a spectator I find myself producing feminist and psychoanalytic readings, as the mother I see in this picture the texture of our home life. The photograph was taken on a Sunday evening during Max's weekly bath. I was usually the one to give him his bath, and often, when Dick had finished the dishes, he appeared in the bathroom, camera in hand. I was generally glad to see him arrive with his camera, always hoping for another beautiful picture of my son, but sometimes I got annoyed when he got in the way as I was washing Max's hair.

I don't remember the actual moment of this picture, nor why I regarded Dick with such hostility. Recently he and I were talking about the photograph because I thought I would include it here, and I voiced my puzzlement at Max's and my expression: "Were we angry at you that evening?"

Dick laughed: "I made you look at me that way." He explained that he opened the bathroom door and commanded us to look at him, knowing that a command would produce in both of us the same immediate, instinctive response—momentary but dramatic hostility. Dick used to be a theater director, and he knows how to get what he wants from actors. By sounding like a patriarch, he produced a tableau of resentment from the subjects of patriarchal authority. The response was so fleeting, I never even knew I'd participated in a drama.

"I imagine," writes Barthes, "that the essential gesture of the [photographer] is to surprise something or someone . . . revealing what was so well hidden that the actor himself was unaware or unconscious of it" (32). The word "actor" here suggests Barthes shares Dick's understanding of the affinity between photographer and theater director.

If Barthes had said "the person" rather than "the actor," this revelation of something "unconscious" would lead to a psychoanalytic version of truth, to the kind of oedipal reading with which I briefly flirted. When we read that something "well hidden" has been revealed, we tend to take this as the very sign of truth, but Barthes's word "actor" implies that what is revealed is not a personal truth but something the person lends her body to portray.

Which doesn't mean it isn't true, but that it is true the way theater can be true: resonant human truths are portrayed even though the actors are conventionally "lying," that is, speaking in character rather than as themselves. The patriarchal melodrama in the bath photo does not reveal some personal truth about Max and me but is rather a piece of theater we have enacted all unawares. Although as a spectator I can appreciate the truth of this drama, it is not part of my experience as a subject.

Family photographs are normally taken to represent the particular family.

But Dick didn't shoot "The Wolf Family" solely for that reason. Seeing the bathroom as a set and us as a theater troupe, he stages an archetypal family. Not a conventional family portrait, "The Wolf Family" instead portrays the conventional family.

Dick's theatrical sense of the family probably has something to do with his having grown up in the theater: his mother is an actress, his father a director. But *Camera Lucida*'s use of the word "actor" to describe the photographed subject, as well as its consistent use of "spectator" to name the photo's viewer, means that Dick's theatrical sense of photography is not simply idiosyncratic. At the very least it suggests a congruence between Dick and Barthes, who tells us in his autobiography that "the Theater" is "at the crossroads" of his "entire *oeuvre*," that "spectacle is the universal category" in which he sees the world.[20]

Dick has always said that his photography derives from his work in theater, but I never understood what he meant by this until I brought Barthes's description of the photographer to bear on his photography. That *Camera Lucida* should help me appreciate Dick's perspective is ironic. Dick does not like *Camera Lucida*; he is offended by its dismissal of the photographer's point of view. As a matter of fact, it occurs to me that I may have chosen to approach Dick's photos with Barthes's book in hand precisely because of this resistance to the photographer's point of view.

Barthes begins *Camera Lucida* by proclaiming his independence from "the troupe who deal with Photography-according-to-the-Photographer" (10). Although he shows and discusses photos by many famous photographers, Barthes chooses to epitomize photography in the work of an unknown, anonymous photographer: "A picture made by a provincial photog-

rapher . . . an indifferent mediator, himself long since dead" (110). In the quintessential photograph (the "winter garden photograph"), the photographer is "indifferent." And Barthes adds, as if gratuitously, dead.

Barthes prefers a photographer who doesn't matter. Perhaps best known for having wrested literature from the author and given it to the reader, Barthes in his last book is occupied with taking photography away from the photographer. Having proclaimed "the death of the author,"[21] Barthes would then go on to bury the photographer.

Thinking about Barthes's relation to the photographer, I cannot resist a psychoanalytic interpretation. Barthes theorizes three subject positions for photography: photographer, photographed subject, spectator. He then typifies photography with an example where he is the spectator, his mother is the photographed subject, and the photographer is "indifferent," "long since dead." Having thus gotten rid of the *operator,* the spectator has the photograph all to himself (Barthes is alone with his mother).[22]

Barthes's relation to the photographer looks pretty oedipal, I have to say. Yet I'd like to be able to say that without disqualifying Barthes's view of photography. I take the oedipal specters in *Camera Lucida* not as disqualification but as marks of the book's project to theorize through his subjectivity; but I fear that this psychoanalytic view will pathologize *Camera Lucida,* condemn it in your eyes.

For pages now, I've been flirting with psychoanalytic interpretation— provocatively bringing it up and then dismissively casting it aside. Thinking about the grain of my family life or the poignancy of Barthes's text, the psychoanalytic reading seems crude. And yet I cannot deny my ongoing attraction to it.

It is not so much that I'm ambivalent about psychoanalysis, but rather I'm trying to figure out how to bring in just a touch of psychoanalysis without having it overwhelm and flatten everything else. Psychoanalytic interpretation is too often heavy-handed; I want psychoanalysis with a light touch.

My fear of the heavy and my wish for the light bring me very close to Barthes here. Since I have voiced a psychoanalytic response to Barthes, I'd also like to remember Barthes's take on psychoanalysis. Having entertained a psychoanalytic view of his theory of photography, I'd like to counterbalance it with his photographic view of psychoanalytic theory.

To see that view, I turn from *Camera Lucida* back to his autobiography, *Roland Barthes,* published five years earlier.[23] *Roland Barthes* begins with forty pages of photographs, including a number of pictures of Barthes's mother, as well as pictures of Barthes *with* his mother. The very earliest of these is a picture of Barthes as a baby on his mother's lap, captioned "The Mirror Stage: 'you are that.'"[24]

"The Mirror Stage" is the title of Jacques Lacan's most famous article. The phrase in quotes ("tu es cela" in the original French) can be found in Lacan's essay, where it also appears in quotes.[25] Writing at a moment when Lacanian psychoanalysis dominated French intellectual discourse, Barthes would seem to frame his relation to his mother through the lens of psychoanalytic theory. But one could just as well say that by means of this photograph Barthes is making an intervention into psychoanalytic theory.

The photo Barthes shows is sweet and sentimental—because of its content and especially because of its form. Not only is it an image of a baby on the lap of an attractive young woman, but it is an oval image, surrounded on the page by a large gray mat. Bringing together two radically different vi-

sions of infancy, the sentimental and the theoretical, the coupling of this photograph with the reference to Lacanian psychoanalysis reads as a sort of joke.

I want to bear in mind the lightheartedness of Barthes's gesture, and I also want to explore what it might bring to our understanding of Lacan's mirror stage, although I'm not sure I know of a way to talk about this that can convey both the playfulness and the seriousness of Barthes's use here of psychoanalytic theory.

Lacan's mirror stage is about the moment in which the baby meets his image. Since baby and mother in Barthes's photo are both looking in the same direction, the caption implies that they are both looking at the baby's mirror image. The caption further suggests that the mother is saying "you are that," thus teaching the baby to recognize his image as himself.[26] This gently reinterprets Lacan's formulation, giving the mother a leading role in the historic moment when the baby takes his image for himself.

I too have a photograph that I would caption "The Mirror Stage". It is a picture of Max, me, and Dick, with the entire image reflected in a large mirror hanging on the wall. The baby looks at his image in the mirror; the mother holds and supports her son, gazing admiringly at his image; the father is at a distance, capturing mother and child with his technology but not touching them, not interacting with them. The entire little family is centered on the baby's image, mother and father both helping construct that image in their typically differing ways.

Lacan specifies that in the mirror stage the baby looking at himself in the mirror cannot yet stand on his own, but is standing with the help of "some support, human or artificial." The support makes possible an image that is more mature, more together, more erect than the baby really is. In this

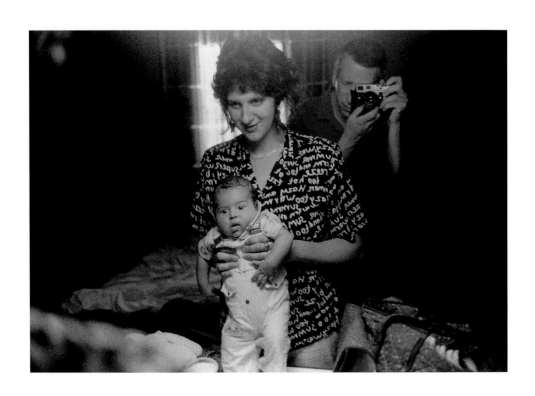

48

photo, Max is two and a half months old; it would be nearly a year until he is able to stand on his own. In this photo, I play the quintessential supporting role for his false and narcissistically pleasing image of self.

Because the baby in Barthes's photo is not pretending to stand, not producing an image that pretends to more than he can really accomplish, the moment does not carry the Lacanian sense of the image's tragic falsity, and the mother's role looks innocuous enough. In my mirror stage photo, I play the same role as Barthes's mother, but since Max is "standing" the role does not seem so innocent.

Lacan locates the onset of the mirror stage at around six months of age, when a baby first wants to be seen standing. Here, more than three months ahead of schedule, it must have been my idea to stand him up. In this picture I can see myself as the worst sort of pushy mirror-stage mother.

Barthes's use of the mirror stage shows us the mother in a scene usually imagined as a solo performance. A closer look at Lacan's text would discern yet another presence, beyond the mother-child dyad. This third presence appears in the sentence that "The Mirror Stage" uses to introduce its description of the infant confronting his image: "This event," writes Lacan, "has often made me reflect upon the startling spectacle of the infant in front of the mirror."[27] The third figure—the one who views the spectacle, finds it "startling," and "reflects upon" it—is Lacan himself, whose reflection has brought us the mirror stage, his most famous theoretical contribution.

Dick's mirror photo shows something like the "spectacle" Lacan "often reflects upon." But this mirror image also includes the gaze that reflects upon the spectacle. When I imagine that this photo represents Lacan's mirror stage, I like to think that Dick's inclusion of himself as part of the image

somehow reveals Lacan's theoretical gaze, bringing the third player in the drama to the stage, allowing us to see the shadowy figure who observes the well-lit image of baby and supporting mother. And this strikes me as a more complete picture of the system that supports the baby's image.

Reading the photo as a further elaboration of the mirror stage depends upon seeing the father-photographer as somehow analogous with the psychoanalytic theorist. I find this analogy enormously seductive, whispering of a grand theorization that would connect the mirror stage to both family photography and the oedipal triangle. I start to fantasize myself as the author of the great psychoanalytic theory of images, which would explain how the image of the self is constructed in the family. But as soon as I try to work it out, the fantasy fades and my writing grinds to a halt.

The caption to Barthes's mirror-stage photo seems to put the phrase "you are that" in his mother's mouth. She thus seems to be doing what *Camera Lucida* says she never does: she is making an observation. And not just any observation, for the words Barthes puts in her mouth are taken from Lacan's text. She speaks not as his mother, but as the Lacanian mother; she speaks psychoanalytic theory.

Barthes's putting Lacan's words in his mother's mouth is a sort of joke, amusing because she was so unlikely to make such an observation. Put me in her place, however, and the joke no longer works. The woman in Blau's mirror-stage photo is quite likely to speak psychoanalytic theory. The proud mother in this 1986 scene is also the author of a book on Jacques Lacan, which came out a few months before Max did.

I have been writing as a Lacanian theorist about the mother in this pic-

ture, imagining her motivations from within mirror-stage theory. I have not been writing as the mother playing with the little baby, entranced by the pleasure he took in stretching his legs against the firm surface of the counter below this mirror. I have viewed my holding him up with theoretical suspicion ("not so innocent," "worst sort of pushy"), as if I did not remember or credit the sweetness of that moment.

That the photographed mother is also a psychoanalytic theorist does not necessarily mean she can speak as both. Rather, I would say that she can speak as either. It does not seem possible to inhabit the two subject positions *at the same time.*

As a feminist psychoanalytic critic, it would be my tendency to see this as a split between psychoanalytic and maternal perspectives, to see it as the problem of speaking as the mother.[28] Yet as a reader of *Camera Lucida,* I discover that Barthes experiences the same split.

Early in the book, Barthes tell us that his "desire to write on Photography" put him in a dilemma. As he thought about this dilemma, he realized that trying to write about photography had "brought to light" a discomfort he had in fact "always known: the uneasiness of being a subject tossed back and forth between two languages, one expressive, the other critical."[29]

One of Barthes's two languages, the one he calls "critical," includes the perspective of psychoanalytic theory.[30] The critical language is Barthes's stock in trade as a critic; it is a language he does not share with his mother: "In a sense I never 'spoke' to her, never 'discoursed' in her presence . . . we supposed, without saying anything of the kind to each other, that the light insignificance of language . . . must be the very space of love, its music."[31]

It is not just that his mother never made an observation (to him); Barthes

never made an observation to her. The space of their love excludes discourse, criticism, observation. Barthes speaks two languages, his professional discourse and a sort of mother tongue, a language he shares with his mother, that allows him to be together with her in a "we" that could "suppose" together, a "we" that shares an understanding "without saying anything."

Throughout this chapter I have experienced a split between writing from my professional perspective and speaking some sort of mother tongue. At the beginning of the chapter, I mapped this split onto Barthes and his mother. I associated Barthes with the critical perspective (observation) and pledged to speak from the position allotted his mother. I see now that Barthes too can be on the side of the mother; Barthes too inhabits both sides of the split.

Recognizing the split in Barthes also opens the possibility of not seeing it as a "split." The English translation of Barthes's realization about his lifelong discomfort reads: "A discomfort I had always suffered from: the uneasiness of being a subject torn between two languages" (8). It was the verb "torn" that allowed me to recognize this as a "split"; but "torn" is not a precise translation. Barthes uses the French verb *ballotter* to say what sort of subject he has always been. *Ballotter* is how one plays with a ball (whence it derives), tossing it back and forth. Whereas "torn" implies some violence (and the translation reinforces that by bringing in the idea of "suffering," not present in the original), *ballotter* is more playful, more lighthearted.

The translation presents us with a familiar theoretical scenario, the subject suffering from a split. This is in fact the subject as theorized by Lacanian psychoanalysis. But just as Barthes's sweet photo of himself on his mother's lap lightens the tragedy of Lacan's mirror stage; so his version of the split

subject is light, so light it can be tossed about, like a ball or like something floating on the waves.[32]

At the end of his life, Barthes was writing books that included both of his languages. *A Lover's Discourse,* written just a few years before *Camera Lucida,* is an explicit effort to bring his expressive language, the "light insignificance" of the language of love, into theoretical discourse.[33] *Camera Lucida* is a book tossed back and forth between two languages, the critical and the expressive, the discourse of his formal knowledge and the language of love he shared with his mother. It is this project of bringing the language he shared with his mother into his theoretical discourse that I want to honor in taking *Camera Lucida* as my model here.

Neither transcending their difference in a grand synthesis, nor tragically suffering from a sense of split as impossibility, *Camera Lucida* takes its irredeemable doubleness lightly, plays with it and derives theoretical profit from it. Doubleness gives the book its form—two halves, one playfully presented as the "recantation," the "palinode" (retraction) of the other (60). And its most recognized theoretical insight—the value of the doubleness of the photo, its famous theorization of the *studium* and the *punctum.*[34]

Wanting to write about photography (about a topic where my knowledge is personal rather than professional), I share Barthes's "uneasiness" of having two languages. And his balanced sense of that moderate "discomfort"— neither integrated ease nor impossibility—encourages me. Barthes knew how to take his "split" lightly, not only to tolerate his different languages but to play with that difference, to great advantage, both as a writer and a thinker. It is above all his lighthearted acceptance of this discomfort that makes *Camera Lucida* a most valuable model for me here.

As I have come to appreciate the lightness of Barthes's relation to theory, I look back at the beginning of this chapter[35]—my psychoanalytic and feminist critique of him, my presumption to go him one better and speak as the photographed mother—and I suffer from the comparison. I don't like how heavy I look.

2 · The Unhappy Woman and the Empty Chair

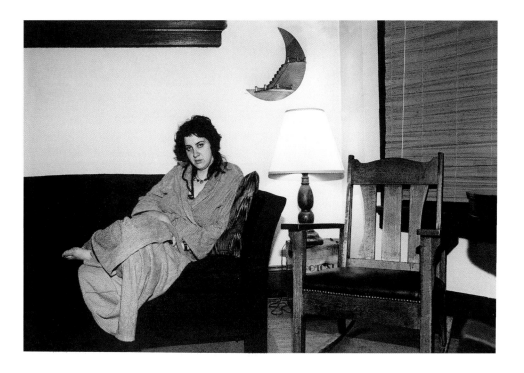

This picture was taken in the same apartment as the cover photo, four years later. While that was our first day there, this photo is from the last day—we move the next morning. The cover photo features the promising light of morning; here it is evening, the blinds drawn against the dark. In the first picture I could be comfortably naked in the summer warmth; in this one I'm robed in chenille against the January cold.

Two picture hangers at the top left mark where something hung over the couch, something now wrapped and boxed. The wooden moon sported a plastic wedding cake couple on its upper balcony, but they're packed away. The honeymoon is over.

I am not happy. I've been crying. Dick and I are having an argument. I'm angry because he's scheduled a film shoot for the weekend we're moving.

Although I am the only person in this photograph, it has two central figures: the unhappy woman and the empty chair. Woman and chair are at the same angle, facing the same direction; this is a portrait of a couple. The flash-illuminated prominence of the chair makes its emptiness palpable, dramatic, as if someone has just left the chair, or is refusing to sit there. Unhappy woman coupled with empty chair: the image suggests the woman feels abandoned.

Which is just what I felt, what in fact I was saying in the argument. Dick's scheduling a film shoot that weekend was, to my mind, a form of abandonment. I wanted him by my side, dealing with our domestic life, but he had made plans to be away from home; he had chosen to be with the camera rather than with me.

The picture stages the very terms of our argument. Rather than by my side, my domestic partner is behind the camera; the man who should be in that empty chair is in fact taking the picture. In the classic conjugal portrait man and woman are pictured together side by side; in this portrait of a domestic argument Dick and I occupy completely different, opposing photographic spaces. In place of the domestic couple, we have instead the photographic couple: he's the photographer, I'm the subject.

"Between photographer and subject, there has to be distance," writes Susan Sontag in *On Photography*.[1] Distance is, of course, literally necessary for focus, but that literal, spatial distance implies something more for Sontag— a less literal, less innocent sort of distance. *On Photography* consistently associates photography with distance: not just the necessary precondition for photography, distance is also its effect. Sontag considers photography a "way of creating distance" (164).

In *On Photography* distance is bad. It is associated with alienation, estrangement, aggression, tourism, domination, and the refusal of experience. Sontag's criticism of photographic distance participates in the romantic critique of instrumental rationality, with its generalized suspicion of technology and mediation. Of course distance affords perspective, objectivity, and clarity, but such "virtues" are all part of the agenda of instrumental rationality and thus all suspect in the romantic apprehension of distance.

Although I use "romantic" here to refer to an intellectual position (literary, philosophical, aesthetic) called romanticism, I mean also to suggest connections to romance. Whatever else the two meanings of "romantic" share—whatever else unites the cultural lineage associated with august names like Wordsworth and Schlegel to the heroine's fervid longings in supermarket love novels—both share the belief that distance is bad.

In fact, although the concept of distance in *On Photography* operates within a sophisticated philosophical critique of contemporary culture, it first appears when Sontag is thinking of the photographic couple explicitly *as a couple*—that is, as a sexual couple: "Using a camera is not a very good way of getting at someone sexually. Between photographer and subject, there has to be distance" (13).

Behind Sontag's worldly pronouncement that the camera is "not a very good way of getting at someone" is a romantic philosophy of sex. This romantic view prizes direct contact of naked flesh and passionate effusion. Good sex here means the absence of mediation: no distance, no gadgets.

In Sontag's critique of photographic distance I hear something that sounds like the complaint of the woman in the chenille robe. The couple should be together, no distance between them, Sontag and I both seem to be saying. The most acclaimed critical account of photography could be said to share a certain perspective with me on the couch feeling abandoned: the view that distance is bad and that the gaze through the camera is suspect, a defense against connection, a refusal of togetherness.

The tone of *On Photography* reminds me, in fact, of how I argue when I'm angry. While Sontag's brilliant analysis of photography has, to be sure, both insight and elegance sorely lacking in my sulky accusation, there is nonetheless a stylistic commonality: the tendency to absolute assertions. When Son-

tag avers that "there is an aggression implicit in every use of the camera" (7), the absoluteness of "every" joined to the culpability of "aggression" and the exposure of "implicit" makes it the perfect point scorer in an argument. ("You *always* hurt me; you *don't even know* you're hurting me!") When I'm in high argument mode, I tend to say "always" and "never," to presume I can see what he's really up to (better than he can), and that what he's really up to is "no good"—selfish, hurtful, and blind to its effects.

Sontag asserts: "Photographs cut sympathy, distance the emotions" (110). The pronouncement is absolute: not some or even most, but simply "photographs," meaning all, necessarily, essentially, just by being photographs. The two juxtaposed phrases equate "distancing" with the more explicitly aggressive act of "cutting." Where once there was sympathy, photographs sever ties and produce distance.

Domestic argument is in itself an experience of distance: two people who expect to be together, side by side, find themselves at odds, on opposite sides, separated. In argument with a loved one, the aim might be not so much triumph as sympathy, rapprochement. The stakes are always, ultimately, the same—we reaffirm union or move toward separation. According to Sontag, "the habit of photographic seeing creates estrangement . . . rather than union" (97). In a lover's quarrel, photographic seeing would thus be a bad habit.

It is not that unusual for Dick to pick up his camera when we're having an argument. When I tell people this, they are generally appalled. Most people seem to share Sontag's sense of photography as a form of distancing. And such distancing seems somehow especially bad in the context of a domestic argument.

Or rather, it seems a really bad thing for a man to do to a woman. The

woman wants sympathy; the man responds by picking up a gadget. Male emotional detachment versus female desire for connection—just what we expect from the heterosexual couple.

If a woman picked up a camera in a conjugal argument, we might see that as her heroic rebellion against male domination. But in reaching for his camera, Dick is acting just like a man. The unsavory characteristics Sontag attaches to photography are those we commonly attribute to men, particularly men who make their women unhappy.

According to Sontag, "what seeing through photographs really invites is an acquisitive relation to the world that nourishes aesthetic awareness and promotes emotional detachment" (111). When Dick picks up his camera in an argument, he indeed is responding aesthetically rather than emotionally. And his doing so looks an awful lot like the clichéd male response to female anger: "You're beautiful when you're angry."

No wonder people are horrified by Dick's taking my picture during an argument. I, however, am not horrified. I don't mind his making photographs during arguments. Truth is, I rather like it.

In fact, in this photograph, as angry as I was, I was cooperating with him. At the time of course I wouldn't have admitted it; it happened wordlessly. But while I could easily have disrupted the photo, I posed for it. By "posed," I don't mean this wasn't how I was already looking at him, but I held my gaze as he picked up the camera, held it for the camera.

Even while fighting, we were collaborating in the making of this picture, in the making of an image of our fight. While we couldn't agree on whether he should work on his film that weekend, we did agree that he should make this picture of my unhappiness.

60

I am fond of this picture; it is a favorite image of myself. I feel like it documents my suffering, that it shows that I was unhappy. And that gratifies me.

According to Sontag, "to photograph is to confer importance" (28). I feel like this photograph takes my feelings seriously. That was in fact precisely what I wanted in the argument we were having (and what I want in our relationship in general): to feel like Dick is taking my feelings seriously. I was hurt because I felt like Dick "didn't see" how bad he made me feel. I look at this picture and know that he saw how bad I felt.

I have liked this picture since he made it eleven years ago, and I knew I wanted to include it in this book, but it was only when I actually began writing about it that I realized how it represented not only my unhappiness but my position in the argument. Looking at this photo, I had always focused on myself, never paid much attention to the chair. Turning to the empty chair allowed me to see that the photo actually represents my contention that Dick abandoned me.

Which really surprises me. I am in fact nonplussed to think that while Dick was verbally countering my claim that he was abandoning me, he was making a picture that expressed that claim. I feel like this photograph takes my side in the argument.

Curious about why he would do that, I mentioned it to Dick the other night at supper. While he agreed that the photo showed my claim that I was abandoned, he didn't seem to think it took my grievance that seriously. It sounded like he considered the picture a sort of joke, mocking the melodrama of the grievance.

I saw red. I was no longer just talking about an argument we had a decade ago, I was back in the argument. But with a new twist: "Don't tell me that," I

yelled, trying to shut him up. "You don't want me to put that in the book!" He looked amused by my anger. "Sontag was right!" I screamed at him.

Sontag had become a figure in our domestic life. By "Sontag" I don't mean the person, of course, but the book *On Photography*. Having decided to write about Dick's photography, I knew I would have to grapple with what is undoubtedly the most influential critical judgment of photography. Dick says that Sontag's book "tyrannized an entire generation of photographers." When I hear that, I feel called to do battle with the awesome Sontag, to defeat her and save him (and his entire generation).

"Sontag" represents the most damning view of what Dick does, not only because *On Photography* is unrelentingly censorious of photography, but especially because its criticism often sounds like an all-too-familiar assessment of men. This resemblance leads me to imagine the book as a powerful, witheringly critical woman—i.e. "Sontag."

Rereading *On Photography*, I found the book disturbingly persuasive. Not just because of what it says about photography, which is so damn smart, so undeniably right. What really disturbed me were remarks the book throws out from time to time about the psychology of photographers—I recognized Dick.

On page 10 I read: "Using a camera appeases the anxiety which the work-driven feel about not working when they are on vacation and supposed to be having fun. They have something to do that is like a friendly imitation of work: they can take pictures." Feeling slightly queasy, I thought of Dick's workaholic discomfort with vacations. And then I thought about how antsy he can be just sitting around the house doing nothing, and how taking photos allows him to be "working" while he is hanging around with me and the kids.

During the several weeks that I was reading and rereading *On Photography,* preparing to write this chapter, I found myself much more critical of Dick than usual. Not as a photographer but as a domestic partner. I hated the chaos of his checkbook; I resented the way he hogged the bed. I saw with renewed sharpness annoying character traits I had ceased noticing a decade ago. I began to fantasize leaving him. But then what would become of the book I was writing?

A reader commissioned by my publisher to review the proposal for this book responded to the title "Living with His Camera" by wondering "what Blau might say about 'Living with Her Criticism.'" While the reader is, to be sure, referring to my scholarly activity as a critic, her query calls to mind the more domestic meaning of "criticism" (as in, "she's always criticizing me"). This slippage between professional and personal "criticism" seems to be very much at work—and on several different levels—in my response to "Sontag."

On page forty-two of *On Photography* I read: "The photographer is super-tourist, an extension of the anthropologist, visiting natives and bringing back news of their exotic doings and strange gear." Besides his family work, Dick's other photography is literally ethnographic. Working in conjunction with a couple of ethnomusicologists Charlie and Angie Keil, Dick hangs out in social worlds far removed from his own, taking pictures. It started geographically close to home: Buffalo (where he lived until 1975) and Milwaukee (after he moved here), with occasional short trips to Chicago. Through the 1970s and 1980s, he photographed polka dances for a book he and the Keils did on Polish American music and culture.[2] (Dick is not Polish American, nor can he dance the polka.) More recently, again working with Angie and Charlie, he has taken pictures of Gypsy musicians in a small town in Greek Macedonia.[3]

Dick objects to my use of the word "Gypsy" here. I knew he would. He and the Keils don't use it, preferring "Roma," the name these people call themselves. I nonetheless chose "Gypsy" because the word's baggage of stereotypical, romantic associations resonates so well with Sontag's mocking the quest for the "exotic." Saying Dick takes pictures of Gypsy musicians sets him up as a perfect example of the touristic photographer Sontag condemns.

Dick is well aware of the critique of exoticism that has made anthropology extremely self-conscious in the years since Sontag wrote *On Photography*. The work he and the Keils are doing is explicitly intended to counter the romantic as well as the more blatantly demeaning stereotypes about the Roma. As Dick likes to say, in order to challenge our stereotypes, "these Gypsies live in houses and worry about cholesterol."

Dick in fact lived in one of these houses when he first went to Greece to make pictures. He lived with Dimitra and Yiorgos, the couple in this photograph. Yiorgos is a professional musician: he plays the dauli, the drum he is shown restringing.

This is a portrait of wife and husband at work, their tasks separated along the conventional gendered division of labor. Facing neither each other nor the camera, each concentrates with remarkably similar expression and direction on her or his own task. Her broom rises through her right hand to her left at the exact same angle as the taut drum lacing passes through his right hand to his left. The repetition of these striking oblique lines underscores the parallel between their activities. This sense of the couple is backed up by the two trees, different but side by side, the one by the husband bigger, the one by the wife demurely draped with some mysterious cloth.

This is a perfect domestic scene, the portrait of a marriage, made more idyllic by its outdoor setting. Dick has access to this domestic moment because he is living with them. The subjects' apparent lack of self-consciousness bespeak their acceptance of living with his camera. The photograph's appreciation of the detail of domestic life, the dailiness and labor, resembles Dick's photos of his family. Except here, Dick is not really a participant-observer. He has little relation to these subjects except as a photographer, little to do here but make pictures.

Ironically, this photograph could be taken to figure the present book. This book, after all, is a sort of portrait of a couple going about our separate work—photography and writing. In Yiorgos here at home engaged in his artistic work, Dick finds an image of his own art making in the family. And I'm amused to think how Dimitra's broom recalls the cover photo.

I find the resonance between this photo and the book ironic because, in order to make this lovely picture of a couple working side by side, Dick traveled thousands of miles away from our house and my side. The picture was taken in summer 1993, when Dick spent a month in Greece. Without a doubt 1993 was the worst year of my life: I was under investigation by the university for sexual harassment and felt in danger of losing not only my job but the career I had worked two decades to build.[4] Feeling particularly scared, vulnerable, and needy, I was not happy Dick was leaving me for such a long time. In short, I felt abandoned.

Five years later, reading Sontag's critique of the photographer as super-tourist rekindled my old grievance. While I didn't actually believe Dick to be the superficial tourist pilloried by Sontag, it was convenient to confuse my personal gripe with her professional criticism. Sontag and I both could find

fault with Dick's desire to go photograph the Gypsies. While the similarity of our criticisms was specious, it was tempting to take advantage of it, to use Sontag to reopen an old argument, this time with new, more formidable firepower on my side. Rather than saying I was afraid to be alone for a month, I could accuse him of touristic exoticism, taint him with ideological suspicion. And rather than having to hash it out with Dick, I could appeal to my reader to determine whether Dick was wrong.

In telling you that Dick left for a month during the worst year of my life, I am unfairly, melodramatically, and completely misrepresenting Dick's relation to me that year. During my troubles he not only stood by me but gave me all manner of support, ranging from practical advice on how to handle the university bureaucracy to the comfort of his abiding love. At that time, Dick was for me the proverbial haven in a heartless world. I should add that the month he was away school was out of session and the case was at a standstill (the investigation was completed; the findings would not be released until later). Dick would not, in fact, have left had there been something I needed his help to deal with. And yet none of that kept me from feeling abandoned.

Here is a photo of me taken the summer Dick went to Greece. I look not only unhappy, but dramatically alone. Wearing denim and sunglasses, I'm girded in toughness, curled up, and turned inward. Nothing offers me comfort; the landscape is stunningly inhospitable—hard, sharp, rocky, dry, and devoid of life. I look as if I've been abandoned in the desert.

Of course I wasn't actually alone: Dick was there with me, or there wouldn't be any photo. And I was far from the desert: Dick, Max, and I were only about a mile from our house, right here in Milwaukee, on Lake Michi-

gan. The photo gives a deceptive sense of my surroundings: you can't see the water a few feet from where I'm sitting, or the grass a few feet in the other direction. You can't see seven-year-old Max playing with the rocks, or Dick with the camera.

Actually, I couldn't see them either. If I was looking at anything it was my left foot, although it's more likely that all I saw was the desert in my head. This photograph is framed in a way that misrepresents my surroundings in order accurately to portray my state of mind.

I'd like to call this picture "Hostile Environment." The phrase describes the landscape in the language of sexual harassment complaints. The title is a piece of black humor about the particular irony of my situation at the time: whereas I had been accused of creating a "hostile environment" for my students, as a result of the accusations the university had become an environment I experienced as completely hostile to me.

This photograph is the very opposite of a domestic scene. It contrasts sharply not only with Dimitra and Yiorgos working together but also with the photo of me unhappy at home. In the latter, I might not be happy but at least I'm comfortable: my body is supported and enclosed by the couch, and I'm robed in softness and warmth. Here on the rocks, nothing supports my body, my posture looks uncomfortable, and I'm wearing rough outdoor clothes.

During that miserable year, I did in fact experience an extreme contrast between private and public spheres. At home, in the family, I felt safe and loved; outside the family I felt isolated and exposed. My name appeared in an unflattering light in the local newspapers. Milwaukee itself felt like a hostile environment.

So here, in public space, out in the city, Dick made a portrait of my suffering. It is not posed, not a fiction; I was really unhappy. I was also unaware of the camera. Not because it was far away or hidden, but because I was completely preoccupied by my misery.

Dick did not interrupt my isolation. He didn't reach out to me, try to comfort me, talk to me, or sit down next to me. Instead he saw in this moment an eloquent image of my suffering, picked up his camera, and captured my misery.

Sontag writes: "Photographing is essentially an act of non-intervention The person who intervenes cannot record; the person who is recording cannot intervene.... The act of photographing is ... a way of at least tacitly, often explicitly, encouraging whatever is going on to keep on happening. To take a picture is to have an interest in things as they are, in the status quo remaining unchanged (at least for as long as it takes to get a 'good' picture), to be in complicity with whatever makes a subject interesting, worth photographing—including, when that is the interest, another person's pain or misfortune" (11–12).

Although Dick did not cause my unhappiness here, Sontag might hold him partly responsible for it. When a photographer looks at someone suffering and, rather than do something to relieve the suffering, he takes a picture, then he is worse than detached, worse than uncaring. He is, according to Sontag, actually profiting from another person's misfortune. He wants the subject to remain in her misery so he can reap aesthetic benefit from it, produce a poignant image that enhances his artistry.

Dick in fact frequently makes pictures of other people's misery. The suffering people are generally his loved ones, usually women and children. If

we follow Sontag here—and her logic is persuasive—I was better off when Dick left me for the Gypsies.

But I don't want to follow Sontag here. She's moving way too fast for me. I want to slow down and retrace her steps. First she reduces photography to a negative act, to what it isn't, "essentially an act of non-intervention." She elaborates on this by declaring recording and intervening mutually exclusive, without explaining how and why they are. Having established that the photographer by definition cannot intervene, she advances from the neutrality she has just "proven" to a more reprehensible complicity. (As we used to say in the 1960s, "if you're not part of the solution, you're part of the problem.") Tainted terms like "complicity" and "interest" show up, until we get to the ultimate culpability—interest in "another person's pain or misfortune." By progressing from photography in the abstract to photographs of suffering people, Sontag makes aesthetic profit from another's suffering seem intrinsic to photography.

Along the way, she hesitates once. For just a moment, Sontag becomes self-conscious about her rhetoric and takes a distance from the absoluteness of her pronouncements. While the long final sentence in the quote above rolls inexorably from phrase to phrase until it reaches its damning destination, its cadences are momentarily broken by a parenthesis. Sontag parenthetically backs off from the abstract logic of her axioms to reflect that the photographer's investment in the status quo might last only "for as long as it takes to get a 'good' picture."

I'm interested in what happens if you plug this parenthetical reflection back into her basic assumption about photography. For example, the assertion that "the person who is recording cannot intervene" would change

radically if we added, "at least for as long as it takes to get a 'good' picture." As it is now, the assertion implies that the person who takes a picture cannot intervene at all, ever, that there are two different kinds of people, those who record and those who intervene. Taking her parenthetical reflection into account would mean that while the photographer cannot intervene during the moment it takes to make the picture, he can afterward: a person can do both, just not at the same time.

While it is true that a photographer who wants to capture an image of suffering can be said to "want" that suffering to last, he wants it to last not forever but only for as long as it takes to record it. He wants it to last but a moment longer.

Of course the moment of nonintervention can, in a way, "last forever." Not because the photographer will never do anything to alleviate the suffering, but because if he manages to get the "'good' picture," the suffering endures in the image.

For example, in order to capture my misery in "Hostile Environment," it is true that, as I said earlier, Dick did not try to comfort me. But this was only for as long as it took him to take the picture. After he shot it, he could offer me his hand, talk to me, sit with me, walk with me. And he did, though the picture cannot show that. It is necessarily outside the frame, like the lake, the grass, and Max playing. Dick did leave me suffering in order to record the suffering, he did in fact want my suffering to go on, to last—but only for a moment, only for as long as it took to get this image.

And I'm glad he did. I'm glad to have an image of my suffering, to be able to see it, reflect back on it. I know he comforted me plenty that year, helped me out, cheered me up, or just kept me company. Contrary to what Sontag

asserts, I know that the person who intervenes *can* record; the person who is recording *can* intervene—just not at the same moment.

Sontag's parenthesis remembers what her main argument forgets: that the moment is not eternity. By mistaking the moment for eternity in her condemnation of photography, Sontag embraces the very logic of photography, which makes the moment last forever. As she puts it later in *On Photography*, "A set of photographs that freezes moments in a life or a society contradicts their form, which is a process, a flow in time. The photographed world stands in [an] essentially inaccurate relation to the real world. . . . Life is not about significant details, illuminated a flash, fixed forever. Photographs are" (81).

I am in fact all too familiar with the logic that mistakes the moment for eternity. That logic is not just photographic, it is also the logic of my anger. Whatever my particular grievance, it seems to be true for all time: "You never listen to me"; "You're always late."

This is definitely the logic of the woman in the chenille robe feeling abandoned. Recall the actual argument I was having with Dick. In my mind at the time, the person who helps with the moving cannot do a film shoot; the person who has a film shoot cannot help with the move. While it is true that one cannot do both of these in the same moment, a weekend is more than a moment. In fact, Dick did go to a film shoot for several hours on Sunday afternoon. But he also did most of the packing preparatory to our move and was there for the entire actual move on Saturday. Then on Saturday night—in a fury of activity provoked by my continual complaining about his film shoot—he unpacked the entire apartment in the space of several hours to give the lie to my presumption that he couldn't do both.

Looking back on it, I would say Dick and I were in fact arguing about whether he could do both: record and intervene, observe and participate, be behind the camera and by my side. I didn't believe he could do both because in my anger I mistook the moment for eternity.

That mistake structures the logic of my overactive sense of abandonment. When I didn't want Dick to go to Greece it was because a month seemed like an eternity. When I said he left me for a month during the worst year of my life, I presented an image that, like a photograph, took the moment of his leaving out of the context of all the rest of the year in which he stood by me.

This logic of abandonment is literally infantile. When mama is gone, baby cannot understand that she will be back in a moment. Baby cries bitterly because she has no sense of the flow of time; for baby the moment is an eternity.

In tracing this lineage of the peculiar temporal logic of photography, I seem to be altogether disqualifying it. I call it a mistake and associate it with the likes of babies and angry women. However, I believe in listening to babies and women crying. Although the lens that takes the moment for eternity has its distortions, there are also things it allows us to see.

In noting how Sontag mistakes the moment for eternity, I seem to have discovered a failing. But that failing is also her insight, the power of her view. It distorts but it allows her to see what in the flow of time, in real time, we too often miss.

The value of this distortion is precisely the value of photography. By capturing the fleeting moment, it allows us to give it its full weight, not just let it fade into the passage of time. In the photograph the moment has the force, presence, and intensity of a baby's perception. And although we know more

74

than babies do, we might also need to know what they know—how to fully credit the moment, to make it real.

In the argument with Dick the weekend we moved, I was being childish. My sense of time was distorted: I overestimated how much time we needed for the move. Dick, on the other hand, was realistic in his assessment that he could do both the move and the film shoot in the same weekend. His mature, businesslike sense of time did not, however, recognize my subjective need to set aside the weekend as a historic moment in our life.

Dick and I were operating according to two different senses of time. While I was objectively wrong in my estimation of what could be done in the time we had, in another temporal logic I was right. I'd say now that both of us were right and also we were both wrong, depending on which sense of time you credit. Which is probably why we can't resolve the argument.

And why it keeps recurring; why a decade later in discussing the photograph of the argument we found ourselves back in it. In the most recent incarnation of the dispute, the one that drove me to invoke Sontag, the question had shifted from whether Dick's film shoot was an act of domestic abandonment to whether my sense of abandonment as represented in the photo was serious or comic.

To me, it seems still the same argument. A sense of proportion, a realistic sense of time makes me look silly for overestimating the moment. From that point of view, my claim that a few hours at a film shoot constitutes abandonment is surely comic—at best. In both the original and the most recent dispute, I am taking the moment very seriously, while Dick is taking it lightly.

Just as I would contend that we were both right (and both wrong) in our

differing assessments of time in the original quarrel, I believe we are also both right in our conflicting interpretations of the photograph. I see now that the photo is, in fact, both serious and comic in its representation of my sense of abandonment.

It depends on which of the picture's two figures you look at. If you look at the Unhappy Woman, it seems a quite serious, even dignified portrait of suffering. And I have to admit that, for eleven years, in considering this picture I only had eyes for that poor, sad woman on the couch. Yet somehow the demands of this book project broke me out of my narcissistic mirroring and got me to see the whole picture, and—when I turned my eyes to the Unhappy Woman's companion—I saw that the photo is indeed unmistakably comic.

The Empty Chair is funny. Lighting and shooting a piece of furniture as if it were a person is funny. Representing my sense of abandonment in this homely object provides a comic view of the melodrama. The seemingly animated chair is a joke about the disproportion between my feelings and the actual situation.

Yet for all its humor, the photograph is also serious. Probably because there is no getting past the real unhappiness the woman in it feels. However comic the chair, the scene, and the framing, the woman still gazes at the camera, oblivious to her comic surroundings, earnest in her discontent, demanding that the viewer recognize her unhappiness. That is my contribution to the photo, my part in the collaboration.

"The Unhappy Woman and the Empty Chair" is, as I said at the beginning of this chapter, the portrait of a couple. Part of the humor of the photo is how mismatched the couple is—the woman smoldering with feeling and her wooden companion. While such an "odd couple" is stock domestic com-

edy, it is also a depressingly familiar stereotype of heterosexuality. Recognizing the classic impasses of heterosexual miscommunication in this photo, I'm tempted to say, in the tones of 1970s feminism: "That's not funny!" (But of course that line is itself a standard joke.)

This photo is not only the portrait of an odd couple; it is also the product of a collaboration by an odd couple. If, even as we were arguing, Dick and I were collaborating in the making of this picture, our agreement to make the photo did not override our disagreement. The photograph in fact represents both sides of the argument in their unresolved tension. While my gaze demands to be taken seriously, Dick's gaze brings levity to the scene. Drama and comedy cohabit the photograph, side by side, making it impossible to decide if the scene is serious or comic.

Although I am here taking credit for the serious aspect of this picture, I recognize that this sort of juxtaposition of comedy with suffering is present in many of Dick's photographs, and not just those that feature me. One might say that Dick has a strange sense of humor, finding comedy in scenes where those he loves are melodramatically unhappy. The comedy lies in the disproportion between the intensity of the misery and the actual situation.

Earlier, under the influence of Sontag, I said that Dick frequently makes pictures of his loved ones' misery, stating it so as to make him look as sinister as possible. I would now like to specify that when things are really bad, he doesn't take pictures. He does not make photos of the serious traumas, the real tragedies, but rather of the little moments of misery that are part of everyday life. He typically makes pictures in which the subject's high sense of drama in her suffering coexists with the low comedy of mundane, domestic dailiness.

Children are particularly good subjects for such photos. Children regu-

larly manifest intense feelings in situations that adults see as not very serious; to us, children's emotions look disproportionate to their causes. And Max who has always been a "sensitive" child—quick to tears, quick to anger, and overly dramatic in the manifestation of his feelings—is a great subject for such photos.

Here's a picture of Max on his birthday. We're out to breakfast, and something has upset him, made him cry. The portrait of him is poignant: one forlorn eye visible, the other hidden by the sleeve that is wiping his tears. But at the bottom of the picture, beneath Max looking precociously dignified in his tweed sportscoat, is a glistening comic mess—the candy wrappers he's left on the table.

This picture of Max on his birthday parallels the photo of me on moving day. In both photos, the somber human subject shares the frame with comic inanimate objects. And in both photos lighting animates the objects, elevating them from background to figure, making them compete with the human subject for the viewer's gaze.

On his birthday, Max is allowed to eat all the candy he wants. In this picture we see the evidence, laid out on the table, of his pursuit of pleasure. But no amount of sugar has sufficed to make him happy. Imagining that on this day he will get his heart's desire makes him especially susceptible to disappointment. In fact, Max is frequently unhappy on his birthday.

Like me in the photo on the couch, Max here in the restaurant is completely involved in the seriousness of the moment. Although I'm aligning my pouty self with Max, it would be wrong to assume that at the moment of this photo my view was any different from Dick's. I was in fact sitting right next to Dick, both of us across the table from Max, trying to show Max a

good time on his birthday. And I too found Max's breaking into tears humorous: it was such a typical Max response to the disproportion between his birthday fantasies and reality. By the time Max had reached this age, we already had a stock of humorous anecdotes about his birthday disappointments, and I was amused to find us back in that familiar genre.

I must confess that, in contrast to my sharp memory of my chenille-robed grievance against Dick a half-dozen years earlier, I have no memory of what specific thing made Max cry here. Even at the time, I did not take the content of his grievance seriously. That, I'm afraid, is what adults, even well-meaning adults, do to children. We look at the intensity of their feelings over things we regard as trivial, and we experience detachment. At our worst, we're annoyed that they're so hysterical and immature, that they blow things out of proportion. At our best, we're amused.

This is a picture of a boy suffering alone in an adult world. The man right behind him has his broad back turned, oblivious to this child's unhappiness. We see a woman and her companion at another table, engrossed in their conversation. Max is not the only human figure here, but he is completely alone.

Max is in fact trying to function in the adult world. He's chosen to wear a coat and tie to mark his birthday. Not only does he want to be "dressed up" to honor the specialness of the day, he also is trying to look "grown up" in order to embody the meaning of his birthday, that he has gotten older. But for all his trying, he's failing here. If the coat and tie are meant to symbolize being grown up, crying is the mark that he's still a child, acting like a baby. And there is something both poignant and comic about his lifting that miniature version of a real man's sleeve, accented by those two haberdashery buttons, to hide and dry the tears that betray his childishness.

80

We have taken him out on his birthday and, rather than that being a treat, it turns out to mean exposing him. Surrounded by windows that open directly onto the street, in the fishbowl of the public gaze, Max is out in the world, suffering from intense, private emotions. Because he is so exposed, even in his suffering he can't completely hide his eyes. One eye looks out miserably, suspiciously toward the street—not in search of comfort but on guard. He must keep watch, cannot completely turn inward, does not even have that solace.

Baby Ruby, on the other hand, shuts both eyes tightly against the outside world, but that hardly suffices to comfort her. Here she is about a month old, in her car seat: like Max vulnerable and exposed in the restaurant, she seems to experience this outing as not a treat but a torment.

Ruby's misery at such a young age seems an image of primal human tragedy—being in the world is just too much to bear. But the banality of the moment, as represented by the mundanity of consumer baby apparatus, makes this an image of the human comedy as well.

Both the tragic and the comic quality are in part a result of camera angle. Dick has managed to take a vertical picture of a baby at an age before she is capable of an upright posture. While she is in fact lying on her back, cradled in this "seat," seat and camera angle combine to make it look like she is upright but with her head bowed. Thus she can more effectively symbolize the human condition—and convey how great an effort that condition represents.

It looks like she feels the weight of the world on her shoulders, but in fact what she seems to be carrying is actually holding her and, far from heavy, is light, soft, comforting foam rubber. It looks like she's tormented by the op-

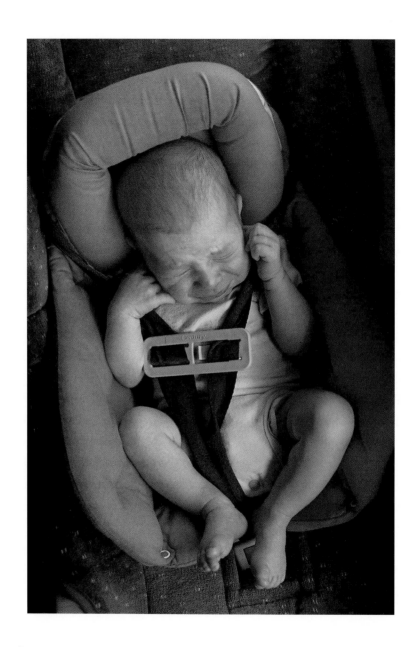

pressive straps that bind her, as if she's grabbing at the shoulder straps in an attempt to rend her shackles and break free. But we recognize this as the safety belt of an infant car seat, which makes the heroic symbolism funny.

While Ruby herself is poignant, the objects that surround her look silly. Like me with the empty chair and Max with the candy wrappers, this is a picture of a person suffering in comic material surroundings, a portrait of the tragicomic discrepancy between human feeling and object world.

At the center of the photo we read the word "Century." Not only is it comical to read a hundred years across the chest of a newborn, but this otherwise dignified word with its historic connotations is here a brand name embossed in a cheap piece of plastic. While from our point of view "Century" is pretentious, from baby Ruby's point of view it is not so ludicrous, since the baby experiences the moment of her torment as an eternity.

Perhaps the most remarkable object in the photo is the foam insert that surrounds Ruby within the larger infant seat. There is something womblike about it. And in its resemblance to the womb, which the newborn seems to be sorely missing here, we see how poor a substitute it is. The resemblance and incommensurability between what Ruby longs for and this object purchased in a store for her comfort is truly poignant and nonetheless funny.

Not yet at home outside the womb, Ruby finds the object world mainly a torment in its obliviousness to her intensely felt needs. This car outing recalls her birth trauma: Ruby is here suffering from exposure and detachment.

Which is also what Max is suffering from in the restaurant. He's a lot older than baby Ruby and more used to the world, but still forlorn. Like the photo of me on the rocks, both of these pictures of the children out in the

world are images of a "hostile environment," of a figure suffering alone in a setting that fails to offer the comfort we so badly need.

I say "we" here, in reference not only to the tragic human condition, but also out of a particular sense of my membership in a set with Max and Ruby. While I use the first-person plural pronoun for dramatic effect, my sense of identification with Max and Ruby is neither simple nor complete but rather mediated, complicated, and split. It is not as the photograph's suffering figure but only as its "reader" that I can perceive my similarity to the children.

In "Hostile Environment" I am completely oblivious to the world around me; in the picture of me unhappy on the couch I do not see the empty chair that is my companion. In both photos I am unaware of the very things that make my situation like Max's and Ruby's. And that in fact is why I am so like them—the three of us dramatically, comically unaware of our environment, of how it looks.

As I said earlier, in a decade of viewing the picture of me mad at Dick, I never looked at the empty chair and thus never saw the humor in the photograph. In all those years my perspective did not depart from my perspective as the photo's subject. In previous viewings, including the one that opens this chapter, I looked *at* the photograph pretty much as I looked *in* the photograph.

It was only when I began to "read" the image, studying it rather than just recognizing me and my feelings in it, that I saw the humor. And it was only when I began to appreciate the humor that I saw how this picture was similar to the photos of Max and Ruby. In other words, in order to recognize myself as suffering *like* Max and Ruby, I needed some distance from my unhappy self and her feelings.

In contrast with my decade-long inability to see the empty chair, I always saw what was funny in the photos of poor Max and Ruby. I had no difficulty sharing the photograph's point of view—perhaps because the photograph's point of view is parental.

Sitting right next to Dick when he took the picture of Max on his birthday, I shared his tragicomic perspective: I felt for Max, wanted to make him happy, but I also found his unhappiness humorous. Although I don't remember the actual moment when Dick took the picture of Ruby crucified in her car seat, I remember well that surviving as the mother of a newborn meant the ability to tolerate her crying without ceasing to care about her needs; I remember how crucial it was to maintain a sense of humor in the face of her seemingly endless demands on my time and my sleep-deprived body.

Parenting, at its best, is a strange combination of caring and detachment. The parental gaze is partially detached.

Dick's tragicomic photos of his suffering loved ones are, I would contend, instances of the parental gaze. And, in that grouping, I would have to include "The Unhappy Woman and the Empty Chair."

His parental viewpoint corresponds in fact all too well with my childishness at that moment. Not only was my sense of abandonment infantile in its temporal logic, but I was literally identifying with ten-month-old Max at the time. In the argument I represented my sense of abandonment as Max's, expressing my anger as on Max's account (not on my own), condemning Dick for scheduling a film shoot at a moment that would be traumatic for the baby, a moment that Max needed him there.

It feels creepy to find in this photo evidence that Dick views me as a child (albeit a beloved child) when I'm acting like a child. It seems to show us in a

bad light. But I believe it also explains why I've always liked this photo—I think it makes me happy to see the parental gaze focused on me.

However I might feel about Dick's viewing me as a child, I too have come to see this photograph through something not unlike a parental gaze. Even though it's an image of me, I now view it in very much the way I see the pictures of Max and Ruby. I've come to appreciate its tragicomic view: while I still identify with my documented unhappiness, I now also find the situation amusing.

"Reading" the photo has afforded me some distance on my suffering self. I am reading this photograph here in accordance with my usual practice as an academic critic, following the way of reading I make it my business to teach my students. The goal of this reading practice is not in fact complete detachment but rather partial detachment.

This sort of partial detachment is for me actually a professional and intellectual ideal. As a critic I want to maintain connection to my subjective experience but rather than just confirm what I already feel, I also want to continue to learn by exploring what is materially out there—in the text, the world, the image. That is of course the project of the present book: to juxtapose personal experience with an acute critical gaze.

Such a juxtaposition may be Dick's project in this photography as well. As an artist, Dick's gaze is professional, distanced, aesthetic, composing the photograph as a work of art; as a family member taking pictures in scenes where he is in fact a participant, pictures of people he loves, his gaze cannot be simply detached. It is the gaze of a participant-observer, hybrid, tragicomic, a strange composite of loving gaze and aesthetic distance—partially detached.

86

Toward the beginning of *On Photography*, Sontag calls photography a "widely practiced amusement," a "mass art form" (8). Although the book will focus specifically on the tradition of art photography, part of its genius is to understand photography through what art photography and popular photography have in common. Popular photography is epitomized in Sontag's account by two practices—family photography and tourist photography. *On Photography*'s treatment of these two practices presents a striking contrast: whereas family photography ("the earliest popular use of photography" [8]) is addressed for two paragraphs and then seems largely forgotten for the remainder of the book, tourist photography becomes *the* model for photography in general.

The model of touristic photography makes emotional detachment facile, troubling, and bad. And it is just such detachment that *On Photography* targets as photography's chief sin. If however we shift our model from tourism to the family, the meaning and value of detachment changes. Whereas the traveler is in a condition of quite considerable detachment from his surroundings, in the family we could all benefit from a little more detachment.

Later in *On Photography* we do once encounter someone photographing his own family. Right in the midst of the critique of touristic photography, Sontag writes: "It required the social immobility of a photographer of genius who happened to be a small child, Jacques-Henri Lartigue, to confine subject matter to the outlandish habits of the photographer's own family and class. But essentially the camera makes everyone a tourist in other people's reality, and eventually in one's own" (57).

As if it were not enough simply to belittle family subject matter by relegating it to "a small child," the next sentence would completely dismiss the

already marginalized exception with a summary "But essentially. . . ." The logic of *On Photography* does not brook exceptions. The exception is immediately followed by a reassertion of the dominance of the touristic model ("essentially . . . everyone . . . eventually")—a dominance so total that the camera even makes the photographer a tourist at home.

As angry as I can get when I feel like Dick is emotionally retreating behind his camera, my experience nonetheless suggests that being a tourist at home is still different from being one abroad. At home Dick has to answer to his subjects—not just out of some abstract sense of ethical responsibility, not only because he loves us, but because he cares whether his subjects love him. In that condition, regardless of what the camera might make him, he can never be more than partially detached.

The Lartigue sentence is the only time *On Photography*'s touristic model confronts family photography. Yet, while it may be exceptional in Sontag's book, the encounter between tourism and family photography is not at all exceptional in the world of popular photography—evidence the common family vacation.

In 1992 Dick, Max, and I went to Jamaica for spring break. Dick had his camera with him, as he always does, but despite the lush, photogenic paradise around us, he chose to "confine his subject matter"—the only pictures he took were of Max and me. For example, this picture of Max sitting on the front steps of our hotel.

"Max as Native Boy" is both a serious portrait of the photographer's beloved son and of course a joke about ethnographic photography. His gorgeous nakedness and big dark eyes belong equally to loving portrait and touristic cliché. Six-year-old Max is not aware of how the hat he was so

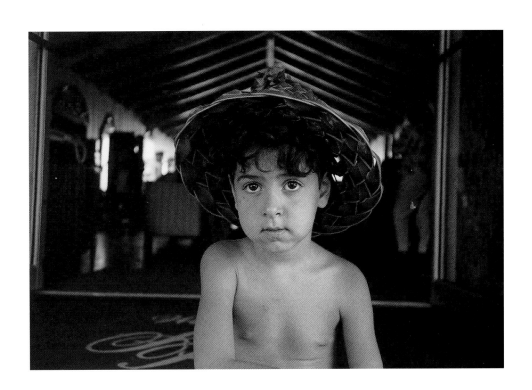

pleased to acquire from a street vendor makes a joke out of his native beauty. But his Dad the photographer is. Dick's gaze here is hybrid, tragicomic, parental, a strange composite of warm regard and ironic distance.

Wherever we go, Dick takes pretty much the same sort of photographs he does at home. (The "mirror stage" photograph in the preceding chapter, for instance, was taken in a hotel room in Tel Aviv.) If Lartigue's family photos serve Sontag as an example of the touristic gaze at home, I'd like to counter with Dick's vacation photos as an instance of the familial gaze abroad.[5]

I want to end this chapter by proposing we rethink *On Photography*'s *understanding of photography and detachment through the practice of fa*mily photography. I propose this not in order to replace Sontag's touristic model with another singular model, but rather to *juxtapose* the two views, place them side by side in their incongruity. The touristic and the familial: another odd couple, perhaps.

3 · The Photographer's Desire

If Susan Sontag *had* wanted to imagine the photographer in the family, she would have invented Edgar Rogers. A character in the 1993 novel *Exposure,*[1] Rogers is the photographer as Sontag depicts him: cold, remote, disconnected from the world, seeing always and only through the camera. Rogers is deficient in human feeling and makes great, gorgeous photographs.

Not just *a* photographer, Rogers is rather a kind of figure for *the* photographer. Although *Exposure* is in some ways a realistic novel, the character Edgar Rogers is more of an allegorical figure. In all things and at all times he functions as a photographer—as if the character's "motivation" were the author's attempt to answer the question "What would The Photographer do in this situation?"

By placing an allegorical photographer in an otherwise novelistic world, *Exposure* examines how The Photographer functions *in the family.* The realist novel is a place for family, a domestic space, a space of emotional entanglement. Rogers belongs to a different world, a black-and-white world— a land of abstraction, of big, flat symbolic moments. The tragic dysfunction of Rogers's family is in reality a breach of literary genre, the intrusion of an allegorical figure into a novelistic world.

Rogers is not a person who happens to be a photographer but rather an exploration of what sort of person the photographer *as photographer* is.

> Edgar Rogers accepted any work he could find as a photographer . . . he was not a participant but a peripheral figure who watched from the edge, his Leica hanging from his neck. Like a name tag, his camera defined his presence . . . Edgar Rogers depended on such identification. . . . He told his students that a real photographer did not consider that there was a difference between his organic eyes and his mechanical one. In the last years of his life, Edgar Rogers wore the Leica all the time. (23)

Rogers is defined by his camera; his identity is man-with-the-camera, i.e. photographer. Always on him, the camera is like part of his body, making him not fully human but some sort of cyborg—part man, part apparatus. His coldness and emotional detachment represent the "mechanical" side of his nature.

The camera defines Rogers's relation to the world, a relation the novel criticizes. The photographer's daughter tells him: "Photography was . . . a construct that blocked your view even if you said it was the camera that let you see" (70).

In *On Photography,* Sontag articulates a similar complaint, providing us with a description of this "construct": "What seeing through photographs really invites is an acquisitive relation to the world that nourishes aesthetic awareness and promotes emotional detachment."[2] Sontag's description here fits Edgar Rogers perfectly: acquisitive, aesthetically aware, emotionally detached.

Rogers's photographic career takes place in the 1970s, the moment Sontag

was writing *On Photography*. In 1973 Sontag published an essay on the occasion of Diane Arbus's 1972 retrospective at the Museum of Modern Art, an essay that would become part of *On Photography*.[3] Sontag's image of the photographer as exploitative and touristic is first developed through her critique of Arbus.

Rogers's career in many ways parallels Arbus's—a retrospective at the Museum of Modern Art, an Aperture monograph. If Arbus epitomizes *On Photography*'s image of the photographer, she also haunts *Exposure*. The novel opens with an epigraph by Arbus; like Arbus, Edgar Rogers commits suicide. Rogers is not only The Photographer, but he is the-photographer-according-to-Sontag.

Exposure in fact covers a lot of the same ground as *On Photography*. While *Exposure* is, to be sure, a novel, I would argue that it is also in its own way an essay on photography. Examining the human life of the photographer, it picks up a number of the psychological themes of Sontag's essay. And then it brings them home.

Exposure takes Sontag's exploitative, touristic photographer and places him in the family. Where he looks really bad.

Rogers's daughter Ann poses for him in his studio for hours at a time; she is diabetic and needs to eat at regular intervals. "Not once, not twice, but too many times . . . the sittings ended in a crisis, but only once in a trip to the emergency room" (54). On that one occasion, when she is fourteen, she poses for so long without eating—the insulin shock is so severe—that she goes into a coma and nearly dies. The trip to the emergency room triggers state intervention. At an inquest to determine if she should be removed from her father's custody, the photographer-father testifies: "I try to remem-

ber that she needs to eat, but when I work I am thinking about the pictures and when I think of Ann it is as a model" (85).

According to Sontag, "photography is essentially an act of non-intervention." Edgar Rogers is nothing if not the *essential* photographer. Sontag continues: "Part of the horror of . . . contemporary photojournalism . . . comes from the awareness of how plausible it has become, in situations where the photographer has the choice between a photograph and a life, to choose the photograph."[4]

Consistent with Sontag's horrific vision, *Exposure* sets photograph and life in polar opposition: "The worse it got and the more passive, pale, and manipulable Ann grew, the better model she became" (54). This polarization makes the father-photographer's testimony particularly chilling: "When I think of Ann it is as a model."

Like the photojournalists Sontag cites, Rogers seems predisposed to choose the photograph over the life. The horror, however, is worse in the novel because the life he discounts is that of his own child. To bring Sontag's emotionally detached photographer into the family is to create a particular kind of unfeeling monster, even more inhuman than the jaded touristic journalist: the selfish, uncaring parent who abdicates his responsibility to nurture and protect, who loves the child's image more than the child.

In the last chapter I argued that, unlike Sontag's photojournalist, the photographer in the family cannot be simply detached. Yet Edgar Rogers represents the very specter I was trying to exorcise: the idea that the camera makes a tourist of whomever uses it, wherever it might be used; that the camera defines the photographer, overriding any human relation. Having expended a good deal of energy and ink in the last chapter resisting Sontag's

94

predatory photographer—trying to open the space for an alternative view of the photographer—why bring him back?

Edgar Rogers not only brings him back, but—worse—he brings him home. I mean by this not only that *Exposure* literally brings him into the family, but that the novel brings it home *to me,* to where I live.

Exposure could have as aptly been called "Living with His Camera." The novel explores what it is like to live one's life in the eye of the camera, with photography as part of family life. And not just any photography, not the usual family snaps, but a photography very much like what I live with, a man making art with his family as subject.

The character Edgar Rogers has two central functions in the novel: he represents not just the photographer but also the father. At first glance, those functions seem simply opposed. The same traits that make him a very good photographer make him a very bad father.

Despite this contrast, there is nonetheless quite another resonance between the two roles. By placing The Photographer in the family, *Exposure* produces a hauntingly resonant image of The Father. Something about Rogers's remoteness, his preference for the image over the life, corresponds uncannily to the archetypal father. Perhaps what seems truly horrible about Rogers is not how abnormal a father he is but how his uncaring yet exacting gaze seems typically patriarchal.

Perhaps Rogers is an all-too-familiar image of the father, particularly to the daughter. A review of the novel in the *New York Times* was entitled "The Photographer's Daughter."[5] Recognizing Edgar Rogers as The Photographer, the title also suggests that *Exposure* is about what it's like to be daugh-

ter to The Photographer, about what sort of father The Photographer is. This portrait of the quintessential photographer as father seems at the same time to capture something about the father-daughter relation. The very traits that make Rogers the allegorical Photographer also make him a father who possesses and haunts his daughter, trapping her in the binds of some terrible and lasting seduction.

Exposure was written by Kathryn Harrison, a writer best known for the next book she wrote—a memoir entitled *The Kiss*. *The Kiss* is the tale of a literal father-daughter seduction, a consummated incest. *The Kiss* is so notorious that it is now impossible to write about Harrison without mentioning it; and it is particularly impossible to ignore in trying to write about her earlier portrait of a painful and damaging father-daughter relation.

Indeed, there are a number of striking similarities between the two books. The father in *The Kiss* is "an accomplished . . . photographer" who "owns a number of large-format cameras and develops his work himself."[6] At several of the dramatic moments in the story, he takes pictures of his daughter. The memoir's daughter-narrator sounds at times like the photographer's daughter: "He stands back and puts the camera before his eyes. . . . My father takes hundreds of photographs of me. I feel that my life depends on my father's seeing me" (88–89).

But it is not his photography per se that makes *The Kiss*'s father most like *Exposure*'s father. It is in fact the central act of the book, the eponymous kiss itself, that best shows his resemblance to Edgar Rogers.

Taking place at an airport as father and daughter say goodbye, "the kiss" is the moment the father crosses the line between paternal affection and explicit sexuality (as they are kissing he puts his tongue in her mouth).

Reflecting back on that incident, the daughter-narrator says: "The kiss is the point at which I begin . . . to fall asleep, to surrender volition, to become paralyzed. It's the drug my father administers in order that he might consume me" (70). It is precisely this power to paralyze that the two fathers share. The narrator of *Exposure* tells us: "Ann shuddered sometimes as her father arranged her into the position he wanted. . . . His will seemed to paralyze her; she was good at posing . . . because she found herself actually unable to move when he told her to be still" (26).

Whereas the father in *The Kiss* wants his daughter sexually, the father in *Exposure* wants to use his daughter to make great art. Despite this difference, the two men have the same effect on their daughters: the father's will paralyzes the daughter, renders her unable to move, unable to resist, suicidally compliant. This resemblance cannot help but affect our reading of Edgar Rogers: if The Photographer already looked bad in the family, his kinship with the incestuous father makes him look even worse.

While the similarities between Rogers and the memoir's father are indeed striking, at the very sites of similarity can be found, upon closer observation, quite telling contrasts. For example, although the incestuous father is quite insistently portrayed as a photographer, he is a particular type of photographer—"an accomplished *amateur* photographer" (54; emphasis added). Rogers, on the other hand, is no amateur. At one point in *Exposure,* he is explicitly and emphatically distinguished from the "amateur."

James Sullivan, a teacher at Ann's high school, develops an obsession with Ann and regularly digs through the Rogerses' garbage cans. After he abducts and harasses Ann, the police search his apartment and find "one hundred and sixty-three photographs taken by Edgar Rogers and identified by the

artist as failed prints he had torn up and discarded. Some were taped together with such care that only close scrutiny revealed the damage; the best ones, those that an amateur would have been proud to make, were framed" (161).

An "amateur" would be proud to make the very prints that Rogers—here identified by contrast as "the artist"—considers "failed." The contrast here between artist and amateur is stark: the amateur would consider accomplished what the artist considers garbage.

This passage, with its image of the "amateur," ends a chapter of *Exposure,* the chapter devoted to James Sullivan. The opening of the chapter introduces Sullivan thus: "When Aperture published an expensive monograph entitled *Ann: Fifty Photographs* . . . one resident of Jessup bought two copies. He kept one for looking at . . . storing it in his bedside table drawer. . . . It wasn't that he was a connoisseur of the photographic art or process: he looked at pictures of Ann while masturbating" (151).

Sullivan not only treats trash like art (framing it), but he treats art like trash. Through that double reversal, the figure of Sullivan connects the amateur with sexual use. Reading *Exposure*'s James Sullivan together with *The Kiss* suggests that the incestuous father's sexual objectification of the daughter is connected to his amateur relation to photography—in explicit contrast with Edgar Rogers's always professional relation to his art.

The memoir's father can be seen as the antithesis of Rogers—not only in his photography but in the very scene of "the kiss" itself. The scene opens: "In the terminal, he puts down the camera case to embrace me with both arms" (66). In order to be closer to his daughter, this father, unlike Rogers, puts down his photographic apparatus. When the final boarding call is an-

nounced, "the kiss changes. It is no longer a chaste, closed-lipped kiss. My father pushes his tongue deep into my mouth: wet, insistent, exploring, then withdrawn. He picks up his camera case, and . . . joins the line . . . disappearing into the airplane" (68).

Immediately after the kiss, as soon as he "withdraws" his tongue, he "picks up his camera case." "The kiss" in fact transpires in the space between putting down the camera case and picking it up again. As if the kiss (and the incestuous consummation it represents) were what would happen if the photographer-father put down his apparatus, put down the "construct" that comes between him and his daughter.

The contrast with Rogers could not be sharper. Ann Rogers complains to her father: "I wanted to be touched not because you had to, posing me, but because you wanted to, because you couldn't help yourself. I put up with the modeling because I wanted to feel your hands on me. I hoped you might betray some affection" (107). The Photographer's daughter longs for him to "betray some affection," to lose control ("because you couldn't help yourself"). The artist never loses control: "You never dared touch me outside the demands of your craft," Ann tells him (34). Edgar Rogers never puts down the camera case.

In contrast with Rogers's remoteness, his cold, demanding gaze, *The Kiss*'s father represents another type of paternal gaze—less controlled, more self-indulgent—the gaze of the amateur, the amatory gaze. Harrison returns the "amateur" to his etymological origin as the lover. The amateur versus the artist; the ardent, sloppy, trashy lover versus the figure of control. The too-warm versus the too-cold father: which, we might ask, is worse for the daughter?

Read in the light of *Exposure, The Kiss* turns out to have a lot to say about photography. Taken together, the similarities and contrasts between the two fathers help us understand Edgar Rogers—not just what sort of father he is but also what sort of photographer.

Despite the benefits, bringing *The Kiss* into our discussion also feels risky. I fear the more famous and more sensational memoir will swamp the novel. Whenever we find parallels between memoir and novel, we tend to take the memoir as the "real story" behind the fiction, to see the fiction as a distortion and, in the name of truth, to see *through* the novel to the memoir lying behind it. While I am intrigued by the resonance between the two books, I want to hold on to the novel, to prize it especially for what most contrasts with the memoir—that is, Edgar Rogers as the image of The Photographer. For it is as a book about The Photographer (and not just any old photographer) that *Exposure* commands my attention and its place in the present book.

In the case of *Exposure,* our tendency to take memoir as the truth behind fiction is reinforced by the particular focus of the texts in question. Just as we tend to see through fiction to the autobiography behind it, we also tend to see through photographs to some reality behind them. Precisely because that reality is posited as "behind"—as hidden, secret, or private—we often imagine the reality behind representation (whether textual or photographic) as sexual.

This slide from representation to the reality behind is especially precipitous when it comes to photographs of children. In her 1998 book *Pictures of Innocence,* art historian Anne Higonnet worries that concern about photographing children moves too fast and too unthinkingly from representation

to reality, from the question of sexual representation to a supposed reality of sexual abuse. She notes in particular "a widespread anxiety about parents who photograph their children intently. . . . Is there something oddly inward about an artistic project that takes one's own children as its subject, year after year? At its most acute, this fear is incest, metaphoric or literal."[7] Following Higonnet, one could argue that, even if *The Kiss* had never been written, *Exposure* would inevitably, by virtue of its subject matter alone, have been haunted by the specter of incest.

Higonnet makes this observation in a chapter about contemporary art photographers who take their children as subject matter. Her central example is Sally Mann, but Higonnet goes on to locate Mann's work in a more general moment and movement: "Nor are Sally Mann's photographs the only ones. . . . Her photographs . . . participate along with the work of many other excellent photographers in a widespread revision of childhood."[8] Among the other photographers Higonnet goes on to consider are Nicholas Nixon and our own Dick Blau.

Sally Mann is in fact mentioned in nearly every review of *Exposure;* her Aperture monograph *Immediate Family* was published just a year before Harrison's novel about the photographer-father. While Mann's work is thus contemporary with the novel, Dick's work is contemporary with the novel's fictive time—like Rogers he photographed his daughter in the 1970s. The Blau photograph appearing in Higonnet's book dates from 1978.[9] 1978 is the year of Edgar Rogers's suicide; it is shortly before the heroine of *The Kiss* is seduced by her father. In that same year Dick made a picture of his daughter Anna with something like the specter of incest behind her.

Anna in the foreground, lost in her contemplation of a few wisps of grass,

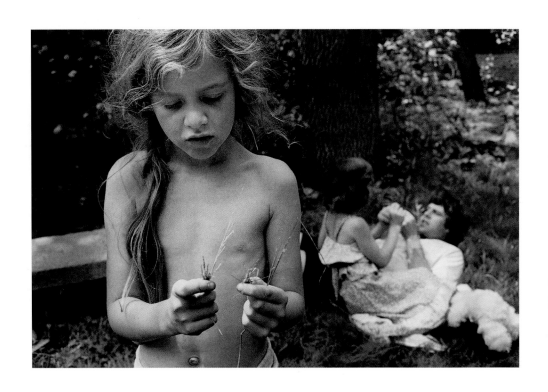

102

is the very image of girl beauty and innocence. On the ground behind her is a father-daughter couple—Dick's best friend Jake and Jake's daughter Laura, Anna's best friend. The background couple could be said to mirror the relation between the unseen father-photographer and his daughter.

Although Laura is but a year older than Anna, in the picture she looks much older; her dress, her posture, her hair bob make her seem in some way precociously grown up. A stuffed animal is lying ignored face down on the ground, as if tossed aside out of preference for the father. The couple is thus behind the backs of both Anna and the stuffed animal, both images of childhood innocence. Something about the couple's posture seems to connote lovers—perhaps in particular the sexy zigzag of Laura's body as she leans on her dad. The photographer's daughter, innocent in the foreground, seems unaware of the father's seduction behind her.

As well as that in front of her. The inclusion of the couple in the background allows the photo to dramatize the erotic exchange that appears in a more conventional form in the foreground, where the father-photographer focuses our gaze on his daughter's delectable skin, sensuous hair, and pouty lips.

The romantic background seems dreamlike in its softer focus and gorgeous light. While the image in the foreground belongs to a large and over-familiar genre—fathers' adoring photos of their daughters' innocent beauty —the background stages the unconscious of the genre. Juxtaposing the manifest and the latent, this photograph both reproduces that genre and reflects upon the taboo eros that underlies it.

Here is another picture of Jake and Laura, taken that same summer. Their relation looks even more explicitly erotic than in the previous photograph.

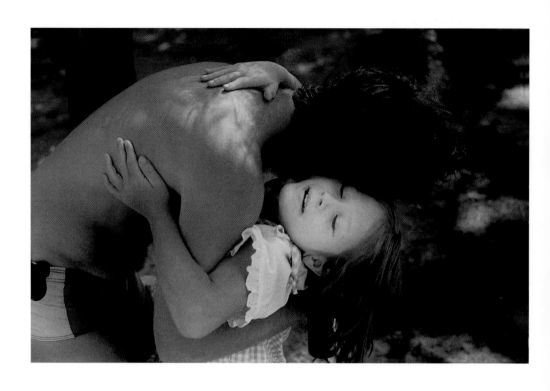

104

First, because of the photo's embrace of Jake's flesh: his beautiful skin takes up a lot of the image; as he bends over her, he is a large, nearly naked body (the contrasting side stripe of his swimsuit insures the viewer's awareness of just how skimpy it is). But despite Jake's luscious, sun-dappled flesh, the photograph and its stunning eros centers on Laura's surprisingly white face, in stark contrast to Jake's dark hair. Completely surrendering herself to her father's embrace, Laura tilts her head back in a posture of ecstasy.

I've seen a number of people, when handed this photo, turn it sideways under the assumption that the image is vertical. (In fact when this photograph was published on the cover of *Frameworks,* it was erroneously vertical.)[10] Laura's face centers the vertical impression, bent back as it is at a ninety-degree angle to her body. His head joins hers in a direction that makes the photo seem vertical. In order to recognize this as a horizontal image, the viewer must register the man as bending over so as to embrace a child who is standing up. But because a first glance immediately recognizes the image of a romantic embrace, the viewer mistakenly assumes that the man is standing up with his arms around a girl just a bit shorter than he. The powerful first impression of romance leads the viewer to misrecognize the generational difference as a more typical heterosexual difference.

The play of horizontal and vertical produces a sort of visual trick, a ghost image, which makes the viewer see something that is not there. Rather than dismissing the viewer's first impression as simply not there, we might think of this insistent if illusory apparition as the photo's unconscious, the specter behind the father-daughter embrace. (The sense of a ghost in the photo is consonant with the strange whiteness of Laura's face. When I asked Dick

about this, he said he actually "held it back," quite intentionally chose in the darkroom to make her face whiter than it really was.)

If we include the ghost image as part of the photo, then once again we see, behind the image of a father-daughter relation, a more explicitly sexual relation where the girl no longer seems quite a child. Just as Laura in the background of the previous photo looks much older than Anna, so the vertical apparition in this photo makes us see a Laura nearly Jake's size, a more grown-up Laura.

Laura is now in fact grown-up, a woman of thirty. Not long ago I attended her wedding, and as the groom took her in his arms, I saw her put her arms around him and tilt her head back in this very posture of rapture.

I was stunned. The photo's ghost image had become a premonition. Whereas in the photo we see something that is in fact not there (Laura's adult sexuality), this latter-day return of the image made me shiver, as if the ghost in the photo were not just a trick, not even just a projection, but the revelation of Laura's unconscious.

There is of course a psychoanalytic explanation for all this. Freud taught us that adult sexuality is shaped by infantile love, that our adult loves repeat the postures of our childhood loves. The photo captures the girl's oedipal desire; what we see on her wedding day is, psychoanalytically, a repetition of that desire.

The psychoanalytic explanation is here stunningly persuasive. (I mean it's just right; I saw it with my own eyes.) What I have called the image's unconscious becomes an image of Laura's unconscious.

This is precisely how I have long understood the other photograph, identifying the background not only as the unconscious but as the daughter's

unconscious desire. I saw Laura and Jake on the ground as if they were Anna's unconscious fantasy revealed; her obliviousness to them reinforced the sense of it as *her* unconscious: it was she who was unconscious of them.

(The first time I saw the photograph of Anna with Jake and Laura behind her, I was writing a book called *The Daughter's Seduction*—a feminist, psychoanalytic inquiry into the daughter's dangerous passion for the father— and this photo seemed the very image of what I was exploring; it seemed to illustrate the female oedipal dynamic. I wanted to use the photo to illustrate my writing, to put it on the cover of the book where the viewer would see through it to my ideas inside.[11] Today, twenty years later, I look at this picture while writing another book, one where my writing is in a different relation to Dick's photography. In this context, I don't want to see through photography to something else; I want to see photography.)

The problem with casting the photo's background as the unconscious is that it leads us to take it as the truth of the foreground exposed. The romantic couple becomes the true meaning of the photographer-subject couple. We see through photography to sex as the truth behind it, the real revealed relation. My reading of this photograph is thus like the reading that turns photography into incest, that reads through *Exposure* to the "real story" of *The Kiss.*

(I confess that I initially chose to write on Harrison because of *The Kiss.* Her infamous memoir intrigued me, first of all, because of a profound if circumstantial identification: *The Kiss* was published the same month as my *Feminist Accused of Sexual Harassment,* and, although Harrison's book had the high profile I could only dream of, the two books were condemned in very similar terms, attacked for telling too much. Moreover, just to add to

the coincidence, my own sensationalist memoir also centered on a French kiss that crossed the boundary between appropriate affection and explicit sexuality.

Beyond this coincidence, *The Kiss* also appealed to me because of my longstanding theoretical interest in "The Daughter's Seduction," an interest that also embraces *Exposure*. In both books, Harrison demonstrates a remarkable understanding of the daughter's desperate love for the father, a subject that has always been all too near and dear to my heart.)

As attached as I am to *The Kiss*, I want now to leave the memoir behind and concentrate on *Exposure*, on what the novel does *not* share with the memoir. Harrison's 1993 novel does indeed teach us a lot about the daughter's love for the father, but, on top of that, it is unsurpassed as an exploration of The Photographer's desire. In this chapter *that* is finally my subject: not father-daughter love, but the question of what The Photographer desires when he photographs his child.

Exposure's view of Edgar Rogers is retrospective. The novel's present time is 1992, the summer the Museum of Modern Art opens a retrospective show of Rogers's work. The majority of chapters take place in 1992, but between them are other chapters that flash back to the period 1967–1979, the years Rogers made his photographs. Every chapter in the novel belongs to one of these two time periods, with the single exception of one chapter that appears near the middle of the book.

It was while reading that one quite exceptional chapter, set in Mexico 1886, that I decided to write about *Exposure*, that I understood how seriously the novel takes its inquiry into photography. This, the only chapter outside

the spatial and temporal frame of the novel, is the story of Edgar's grandfather, Michael Rogers. Quite by chance, Michael becomes a professional photographer in nineteenth-century Mexico. The Museum of Modern Art's 1992 retrospective of Edgar's work includes eight of Michael's ferrotypes. The inclusion of the grandfather's photography in the one-man show works very much like the inclusion of the one odd chapter in the novel: they both suggest that the image of Edgar Rogers as photographer somehow includes the work of his forefather in another place and time.

After Edgar Rogers's death, Ann finds "one hundred and sixty-seven portraits, mostly of children, all taken by [Michael] in 1886. Aside from a few letters to his dealer, this was the only personal legacy left by her father, the only hint of his past, his heritage" (113). Edgar Rogers's "only personal legacy" is in fact not "personal." Like the letters to his dealer (one of which appears in the novel) these portraits are the remains of a photographer.

Although the novel tells us about Rogers's paternal grandfather, his inclusion is exceptional, not part of a larger exploration of family background: for example, we learn nothing about Michael's son, Edgar's father, not even his name. *Exposure* is not a family saga that spans generations but rather an inquiry into the peculiar situation of The Photographer in the family. What matters are only those places where photography inhabits the family. The central relation of the novel is not a father-daughter relation, but a photographer-model relation that is also a parent-child relation. Michael Rogers is in the novel not as part of the family of Edgar Rogers the man, but as the progenitor of Rogers the Photographer.

The relation between Edgar and Michael Rogers is completely mediated through photography: "Edgar Rogers never met his grandfather, but Ann

could imagine what her father felt at the discovery of the photographs. . . . her father would have found them beautiful—any artist would have, anyone who cared for good photography. Like the work of Julia Margaret Cameron or Lewis Carroll, each was lovely, and the passage of so many years excused affectation" (114).

What Ann imagines Edgar feels about his grandfather's photographs has nothing to do with their familial relation. He feels about them what "any artist would have, anyone who cared for good photography." Edgar responds not as the grandson, not as the blood relative, but in his capacity as artist.

The appearance of Cameron and Carroll here is the only instance where *Exposure* names actual photographers. The chapter devoted to the grandfather is the place where the novel opens onto the history of photography. What might appear at first as a piece of family history is actually the site where the novel inscribes Rogers in the history of photography.

The same two photographers who appear together here are also paired by art historian Higonnet: "Going back to photography's first heroic age, consider . . . Lewis Carroll and Julia Margaret Cameron. Both took great photographs of children in the middle of the nineteenth century, for opposite reasons. . . . Carroll and Cameron occupied opposing positions in the perennial photography debate. Is it mechanical representation or is it art?"[12]

While Higonnet insistently opposes Carroll and Cameron, by that very move she also pairs them, repeatedly links them together. The combination of their opposition and their commonality allows them as a pair to be representative. Their opposition represents the two poles between which photography exists. Edgar Rogers, portrayed both as mechanical and as an artist,

combines both poles in his nature; he is not a particular photographer who would be located somewhere along the spectrum between mechanics and art—he is precisely The Photographer.

Despite their opposing views of photography, Cameron and Carroll nonetheless share a particular focus—"both took great photographs of children." If *Exposure*, like Higonnet, pairs Cameron and Carroll, it is because the novel is covering the same territory as Higonnet, exploring the image of the child, in particular as it intersects with the history of photography.

Just as Cameron and Carroll appear briefly in the chapter Harrison calls "Mexico, 1886," nineteenth-century Mexican photography likewise makes a cameo appearance in Higonnet's book, in the chapter exploring the work of Cameron and Carroll: "One of the most characteristic Mexican photographic traditions of the nineteenth and early twentieth centuries was the infant mortuary portrait . . . [photographs of] the tiny dead children they call *angelitos*."[13]

These were in fact Michael Rogers's specialty: "It was during the meningitis plague of 1886 . . . that [he] had his most lucrative year. . . . Most popular, most indispensable, even for the poorest people, were pictures of the *ángelitos*, the dead children dressed in little black suits and white lace frocks" (111–12).

Michael's *angelitos* are the model for Edgar Rogers's photography: "The pictures Edgar took of his wife, Virginia . . . attempted the same mystery and grace, the beauty of the *ángelitos*, of flesh arrested in innocence" (114). (The earliest of Edgar's photos in the retrospective are the pictures he took of his wife, who died giving birth to Ann.) In these early photographs, he "attempted" to produce something like the *angelitos*.

"Attempted," but did not completely succeed: *Exposure* is very clear in its demarcation of the turning point from Rogers's early "attempts" to his later artistic successes. The omniscient narrator states that it was on a September day in 1967 (eight years after Virginia's death and Ann's birth) that Rogers "took the first great photograph, his first real photograph": "He found his daughter lying under the bleachers, stood watching her as she slept, so still. He squatted . . . put the camera to his eye, and composed a shot. . . . It looked as if she were unconscious, or dead" (25).

Michael Rogers became a photographer by accident (his rich employer died suddenly, leaving Michael his photographic equipment and supplies). It is likewise by chance that a meningitis epidemic led Michael to make the *angelitos,* pictures of children who are dead but look as if they were sleeping. Eighty years later, Michael's grandson happens upon a great photograph, one where a child is sleeping but looks as if she were dead. The "first real photograph" does not just launch "his career as an art photographer"; it also begins a series. Once Edgar is launched as an "artist," he moves beyond the realm of accident. Having stumbled across a photograph that captures "the mystery and grace" of Michael's *angelitos,* Edgar will quite intentionally reproduce the lucky find again and again: "Cautious, he stuck with a successful theme—Ann posed as if dead" (26).

When Edgar comes upon his child looking as if dead, he finds what he's been looking for and meets his destiny. On that September day in 1967 not only does he make the "first real photograph," not only does he launch his artistic career, he comes into the inheritance left to him by Michael. He becomes the rightful heir to the photographs "like the work of Julia Margaret Cameron and Lewis Carroll"; he takes his place in the history of photography.

In the introduction to her book on the photography of Carroll and Cameron (a book roughly contemporary with *Exposure),* art historian Carol Mavor writes:

> Photography was invented hand-in-hand with our modern conception of childhood. The child and the photograph were . . . developed along-side each other . . . laminated and framed as one. . . . both our image of childhood and the photograph (mythically) keep time still, innocent, untouched. . . . Both the photograph and childhood accept their shape and their poignancy from death."[14]

If we follow Mavor here, not only does photography have an essential re-lation to childhood, but that relation is haunted by death. Thus the picture that makes Edgar Rogers an artist is not just any image but photography's quintessential image, the image of the child getting its "shape and poi-gnancy from death." In building a career upon the repetition of that image, Rogers becomes not just any photographer but the quintessential photogra-pher.

We might recall here that in *Camera Lucida* Roland Barthes derives the "essence" of photography from a picture that is likewise an image of a child made poignant by death (the winter garden photograph of his mother). Centered on a similar image, evoking its history in nineteenth-century photography, *Exposure,* like *Camera Lucida,* tries to get at the essence of photography, studying it in an unorthodox, narrative mode. But whereas *Camera Lucida* wants to exclude the photographer from photography, *Exposure* embodies the question of photography in the figure of the photog-rapher. Unlike Barthes, Harrison asks the question of The Photographer's desire.

By The Photographer's desire, I mean not what any specific individual photographer might desire, but what motivates the generic photographer, what makes people in general want to take photographs. According to Higonnet, "about half of all photographic film processed in the US today features the very young."[15] Where Mavor suggests that photography had at its origin some intrinsic link to the child, Higonnet's statistic suggests that link is alive and well today.

James Kincaid, in another book roughly contemporary with *Exposure*, shows our present relation to the child to be the legacy of the Victorian image. Although Kincaid focuses on Victorian literature, he speaks eloquently of photography today: "We might ask ourselves why we photograph our own children with such intense and confused emotions, and why manufacturers of film sell us their product by promoting, to the virtual exclusion of all other lures, the claim that their product will enable us to impound the child, hold it forever."[16] By speaking of the "intense and confused emotions" we feel when we photograph our children, Kincaid would seem to be speaking of something like the photographer's desire. What he suggests here is that the desire is to "impound the child, hold it forever."

Kincaid's question—why we photograph our children with such intense and confused emotions—is a version of this chapter's central question. I see that question posed in a particularly poignant way by *Exposure*. The novel centers on Ann's attempt to understand her father, and *that* indeed is Ann's question: What does her father, The Photographer, want?

According to Kincaid, we are nearly all of us impelled by the desire to capture the child on film: "Photographing children before they slip away, before that 'bloom' can no longer be caught, is a need felt by Lewis Carroll, by J. M. Barrie, and, judging by the television and magazine advertisements of film

companies like Kodak and Polaroid, by nearly everyone today."[17] Like Higonnet and Harrison, Kincaid traces the contemporary image of the child back to Lewis Carroll. But, whereas Higonnet and Harrison (focused specifically on photography) pair Carroll with Julia Margaret Cameron, Kincaid's literary view of Victorian culture pairs Carroll with J. M. Barrie.

Barrie is best known as the creator of Peter Pan, the boy who would not grow up. That figure, splendidly arrested in the prime of boyhood, rhymes with the photographic desire to hold the child forever in childhood. Barrie's (and our) love for Peter Pan is another version of the photographer's desire.

Edgar Rogers not only tried to impound his child's image on film, but actually attempted to undo the effects of her growing up: "She submitted . . . to his bleaching her hair which had turned brown at the approach of puberty. . . . So that not even a hint of brown hair would show, they bleached her roots every weekend" (76). Desperately staving off "the approach of puberty," the photographer labors to keep Ann the image of girlhood. The "approach of puberty" is here literally the loss of the "golden" age, of the child's golden locks. (Ann's diabetes itself marks another loss of childhood glory: its onset occurs at age twelve.)

Edgar Rogers did his utmost to keep Ann the image of childhood. But, as J. M. Barrie wrote on the first page of *Peter Pan,* "all children, except one, grow up."[18] *Exposure* introduces Edgar Rogers at the very moment he can no longer maintain the illusion of Ann's childhood:

"It won't work, Ann. You're too old. I can't use someone with, with— . . . Breasts." . . . "They're not new! I'm sixteen! Besides, I'm so skinny they hardly show." . . . "Put your clothes on, Ann," her father said . . . showing her the door. (3)

I find this scene of paternal rejection enormously painful. And yet, ac-

cording to Kincaid, such rejection is the inevitable downside of our adoration for the child: "With children who have stopped being children, who misplace childhood along about (exactly at) puberty, at which point we drop the camera, start screaming at them . . . and long for the day they'll leave home."[19]

While the vision of us "longing for the day they'll leave home" is dramatically extreme, it is also extremely resonant with Harrison's scene of Edgar Rogers's "showing [his daughter] the door." Kincaid's portrayal of puberty as the moment "we drop the camera" implicates the photographer's desire in this scene. Kincaid and Harrison both oppose the photographer's desire to the child's growing up. Growing up is a threat to the image; the child's growing up is feared and resisted by those who adore the image of childhood.

This sense of growing up as a threat suggests another way to read the two photographs by Dick introduced earlier in this chapter. In both photographs an image of a more grown-up girl lurks behind the radiant girl-child. Earlier, reading in the shadow of *The Kiss,* I saw those pictures as haunted by the specter of incest. Reading now in the light of *Peter Pan,* I might see those two photos as haunted, not by the premature loss of childhood through sexual abuse but by the less lurid and thus perhaps more frightening specter of the inevitable loss of childhood in growing up.

This photograph of Max as Captain Hook might serve as a reminder that, however much *we* might desire the child not to grow up, the child's desires may well be located elsewhere. As taken as Max was with *Peter Pan,* it was never Peter he wanted to be. For a year of quite obsessive play, Max was always Hook—compelling me as the obsequious Mr. Smee and Dick as the

116

abashed Starkey to endless repetitions of "aye, aye, sir." As desirable as grown-ups might find Peter, it was Hook the four-year-old Max found glamorous. One of children's most ardent desires is precisely to grow up. When we resist or fear children's growing up, we resist or fear their desire.

But in this photo Max doesn't exactly defy the photographer's desire. On the contrary, he delights it. Dressed up as Captain Hook, he is more adorable than ever. Children playing at being grown-up reinforce our confidence in the gap between them and adult life. The mustache I've drawn on with my eyebrow pencil does not make Max manly or menacing but serves to draw our attention to the moist, plump lips (the mustache even crudely mimics the lips' cupid's bow) and the little round nose of his childish prettiness—the contours of his face are all so soft and round. The mustache also resonates with the wisps of hair escaping from his hat and, as the only dark spot in the middle of the photo, it echoes the darkness at the top: hat, eyebrows, eyelashes, and those big brown eyes looking so earnestly, so serious and trusting, up at the paternal camera. At the bottom of the picture, the sword, far from menacing, has become the perfect foil for the father-photographer's gaze. The camera loves that sword. Here it is not Max who is playing with the sword but his father the photographer who plays with it; now glinting and dazzling, the sword has become part of the photographer's arsenal, a weapon to help him capture the light.

Captain Hook belongs of course not to the adult world, but to Neverland, the world of children's play. He is the feared, hated, envied, and admired grown-up as seen by children. Barrie's genius as a lover of children was to capture not only the boys he adored but the world as they saw it, the world of their desire.

Kincaid's association of J. M. Barrie with the photographer's desire is seconded by Carol Mavor. Barrie plays a crucial if cameo role in Mavor's book on Victorian photography. The book's introduction concludes by quoting from the first page of *Peter Pan*, and pairing Barrie with Lewis Carroll (and with Kincaid):

> Both the photograph and childhood accept their shape and their poignancy from death. If there were no death, why would childhood hold its appeal? If there were no death, why would our desire to photograph and to preserve lost moments be so urgent? "All children, except one, grow up," wrote Barrie. . . . As Kincaid morosely reminds us, children "grow up with the speed of darkness." Is it any wonder that Alice, Lorina, and Edith Liddell and George, Jack, and Peter Davies have been relentlessly preserved by Carroll and Barrie (not only in ink but also) in emulsion? Their pictures are no more and no less than a keepsake of a golden splash.[20]

J. M. Barrie, it turns out, also took photographs. Mavor's introduction includes only two images: Lewis Carroll's photo of Alice Liddell (model for his fictional Alice) and her two sisters, and Barrie's photo of Peter Davies (model for his fictional Peter) and his two brothers.

Where the coupling of Carroll and Cameron gives us poles to span the range of photography's ambitions, juxtaposing these two images by Carroll and Barrie produces a different opposition. Carroll photographed and adored little girls; Barrie photographed and adored little boys. When Mavor (following Kincaid) brings Carroll and Barrie together under the sign of the same desire, it is to suggest that, whatever any particular photographer's

preference, the essential "desire to photograph and to preserve lost moments" takes as its object not the girl or the boy, but the child.[21]

Exposure produces a similar effect by situating Edgar Rogers's images of Ann in the tradition of the *angelitos*. Inscribing Rogers in the history of photography removes The Photographer's desire from the particular father-daughter orbit of *The Kiss* to locate it in the more generalized tradition of the desire to impound *the child,* to preserve it "in emulsion." Michael Rogers's *angelitos* can appear either in "white lace frocks" or in "little black suits."

The *angelitos* are the literal image of the death that haunts both the child and photography. In *Exposure* the *angelitos* remain background, prototype, not what The Photographer does. Where Michael in nineteenth-century Mexico made photographs in which a dead child looked as if it were sleeping, Edgar made photos in which a sleeping child looks as if it were dead. As if the *angelitos* are the negative out of which Rogers develops his images, his art.

Rogers's photography corresponds to what Higonnet calls "the image of the Romantic child," an image she says "is haunted by death."[22] Higonnet's book traces the image of the Romantic child back to late-eighteenth-century academic painting (Reynolds, Gainsborough), and then follows it as it came to inhabit the medium of photography. Higonnet's Romantic child is very much the child Kincaid traces from Victorian times to the present. That child is the apple of the photographer's eye.

When Edgar Rogers happens upon the photograph that launched his career, he happens upon "the image of the Romantic child."[23] In that image, death is not fully present, but rather a spectral effect:

> She slept the way children sleep, deeply, and with a surrender never ob-
> served in adult rest.... That was the day her father took the first great
> photograph.... He found his daughter lying under the bleachers, stood
> watching her as she slept, so still. He ... put the camera to his eye, and
> composed a shot.... It looked as if she were unconscious or dead ...
> the knives of shadow cut across her throat, severing head from torso.
> The peculiar light made a halo of her fair hair, and evoked a certain
> anxiety. Surely, any viewer of the picture hoped, death could not effect
> so perfect a balance. (24–25)

Ann here is not so much a girl but a child, sleeping "the way children sleep." The child's hair is, of course, golden, which the light then makes into a halo, making the child otherworldly, more like the *angelitos*. Thus the anxiety: the viewer worries the child might be dead because death haunts the image—the unworldly halo, the severed head. The threat is most salient in the "knives of shadow," as if in the world of photography life is menaced by what obstructs light.

> What grounds the appearance of death, however, is neither the halo of
> light nor the knives of shadow but the child's deep sleep. Ann sleeps so
> deeply she looks "unconscious or dead." And she sleeps that way *be-
> cause* she is a child, sleeping "the way children sleep, with a surrender
> never observed in adult rest."

In this construction, whereas children "sleep," adults only "rest," implying that adults always remain to some extent wakeful, vigilant. Harrison's word "observed," however, suggests that what makes children's sleep unique is not necessarily that adults don't sleep like that but that we cannot catch them

like that, cannot observe adults in the same way that Edgar "stood watching her as she slept." The real "surrender" of children's sleep is their surrender to our gaze.

Dick has taken countless pictures of his children sleeping, of his children sleeping deeply, "the way children sleep." How often when he happens upon a child sleeping is he moved to go fetch his camera! Over and over again he takes pictures of the children fast asleep.

Here is one of my favorites. In this picture Max is the very image of the Romantic child, with his beautiful curls kissed golden by the light, his gorgeous, smooth flesh bathed in light. His lips are full; his cheeks fuller; his face puffy with a combination of deep sleep and childish chubbiness. While his left leg modestly, coquettishly makes him neither boy nor girl but only glorious, delectable child, his right arm is thrown open in a gesture that surrenders his body to our gaze. Instead of genitals, our gaze enjoys the most childish (shallow, lighthearted, and gender free) of orifices, the belly button, here stretched open and extended for the viewer.

And, as Higonnet or Mavor would predict, dark shadows loom behind the radiant, undefended Romantic child. At the far back of the image is the unlit lamp, casting not light but shadow. Although this is in fact my own bed, I cannot identify the dark mound swollen up behind Max, although it seems already to have swallowed his left arm. (Shades of Captain Hook's crocodile in this amputation, perhaps?)

Here is Max fast asleep again, still the Romantic child but with a difference. Same sunkissed curls, same smooth flesh, still free of gender even though he's now clothed. Same chubby cheeks too, except here they're even chubbier, beyond cute roundness, somewhat grotesque, distorting the form

124

of the face. He's sleeping so deeply his mouth gapes. The open mouth is an aspect of his unconsciousness and vulnerability, but it also looks silly.

Where the previous picture is serious, romantic, maybe even tragic, this one belongs to a lighter genre. The difference may be literally one of tone. While the previous photo is a nighttime interior shot, this one is taken in natural daylight; it is in many ways a sunnier image. Not only is this photo generally lighter, but it doesn't invoke a metaphysical opposition between light child and threatening darkness. Where the previous photo dramatizes a high contrast between looming blackness and radiant white child flesh, this one is largely in midtones, diverse shades of gray. The shadows in this picture are not ominous but transparent.

While there is black in this photo, its effect is not at all like the looming background in the previous picture; the black here is not threatening but reassuring. In the previous photo, the black brings uncertainty—What is the dark mound? what happened to the child's left arm?—here it brings definition. Whereas in the previous photo the black background threatens to encroach on the luminous treasure in the foreground, here black draws a line separating background from foreground.

The only black in the photo frames the car's windows, providing sharp boundaries between the vehicle's interior and the exterior landscape. The black frame produces the outside as a "picture," a framed landscape. This framing effect within the photograph distances the outside world from the sleeping child, a photographic distance we might call "touristic."

Like the last picture in the preceding chapter, this photo is a family vacation shot; we are driving through Louisiana. Outside the window is the exotic landscape, the stuff of picture postcards, vacation slides; inside the

window is the deeply sleeping Romantic child. The dominant black frame divides and juxtaposes two typical photos, one quintessentially exterior, the other quintessentially domestic.

Between this milk-fed Wisconsin babe and that tropical landscape is the car's emphatic black frame, containing the child, containing the landscape, rendering the encounter between the two superficial, touristic, not serious, light. With sleeping child and pillow, the family car becomes the mobile domestic, home on wheels with windows on the world, the world become a picturesque "view." That relation—where we view the exotic world from the comfort of home—is the pleasure afforded us by *Look* or *National Geographic,* as well as by the framed windows of our televisions. This is the relation to the world Sontag diagnoses as quintessentially photographic.

The window here, however, is open. Its openness echoes Max's open mouth, and signals a vulnerability. The open window means a breach in the protective frame, and in fact there is an invisible danger just outside that open window.

Rolled down as far as the back door allows it to go, the window does not completely disappear into the door, thus conveniently allowing us to see that it is open. The edge of the open window parallels and echoes the shoreline just above it on the photo. This doubling of edges makes the line between car and outside like the line between shore and water, as if the water were the outside of the outside, the space most opposed to the comfortable, familiar car interior.

Although we can't see it in the photo, there actually is something scary in that water—this is Avery Island and there are alligators, lots of alligators, just beyond that open window. While in Louisiana, we drove here

specifically because Max wanted to see alligators, but he's fallen asleep on the way. You can tell Max isn't really Captain Hook because the alligators don't disturb his sleep.

While we can't see the alligators in the photo, the photographer knew they were there. Their invisible presence is part of what he saw when he took this photograph of his child fast asleep. The alligators are thus in some way kin to the dark mound looming behind Max asleep on the bed: they belong to the threatening world beyond the power of our gaze, the world of uncertainty, the dark world outside the reach of the photographer's mastery. Like the shadows looming in the previous photo, the alligators represent the death that haunts the image of the Romantic child.

But they represent that death in such a silly, sensational way, in such a childish way, that the threat of death becomes more of a joke. (There may even be a joke in the echo between the open window, the gaping mouth, and the imagined threat of a gaping alligator mouth.) This photo contains the elements of the Romantic image—the innocent, unconscious child, the threat of death—but it plays with the image; it is a lighthearted version of the previous photograph. The child's Romantic beauty is here too, but rendered comic, edging as it does into the bodily grotesque—the latter certainly a widespread and familiar aspect of childhood, though not of the Romantic child. Gently, affectionately mocking the Romantic child, this photo brings him out of the hothouse atmosphere of ideal, innocent, doomed beauty into the light of day.

Edgar Rogers began his career by chancing upon his child fast asleep, coming upon the very image of the Romantic child, haunted by death. Had he

shown up a few minutes earlier, he'd have discovered quite another image, one he never sees but which the narrator of *Exposure* shows us. Here's what the eight-year-old child was doing on that historic day just before she fell asleep:

> Ann sat alone in the gray dirt and began to trace drawings. She cleared a space in the litter . . . and made herself a drawing board which she neatly outlined with a deep scratch in the dirt. On this slate she drew pictures with a popsicle stick and then brushed them off and started again. . . . Finally, she curled up on her side in the dirt and went to sleep. (24)

Harrison's description is itself photographic. With its "gray dirt" and complete lack of other colors, the scene is like black-and-white photography, like the kind of photography Rogers makes. This is the picture Rogers never took.

In showing us this scene, Harrison shows us what Edgar Rogers never saw—the child making her own pictures, the child as artist. Ann Rogers in fact became a photographer after her father's death, got an M.F.A. in photography, makes her living as a videographer.

Unable to see Ann apart from the Romantic image of the child, as other than the object of the photographer's desire, Edgar could not see her as a subject like him, as someone with artistic ambition. *Exposure* shows us what he could not see, the photograph he could have taken had he come upon her a few moments earlier.

Dick, it turns out, has taken just such a picture.

The central event in the novel *Exposure* is the 1992 opening of a photography exhibit at the Museum of Modern Art in New York. A year earlier, in real life, the same Museum of Modern Art opened a photography show called "Pleasures and Terrors of Domestic Comfort," a group show that would undoubtedly have included Edgar Rogers's work if he weren't fictitious. Whether or not *Exposure* is intentionally alluding to this specific show, Harrison's 1993 novel and the actual 1991 MoMA show both participate in a general high-profile awareness, at that moment, of photographers making art in and of their families.[1]

There is another crucial date in *Exposure* that, like 1992, could also represent a moment in the history of photography. Edgar Rogers's artwork begins in 1967. That is the date of what the novel calls "the first great photograph, the first real photograph," the picture of his daughter that "launched" "his career as an art photographer": 1967 is an inaugural moment. That year might also represent an inaugural moment in the real-life conjuncture of high-art photography with family pictures. The introduction to "Pleasures and Terrors of Domestic Comfort" locates the beginning of family art photography "in about 1966."

This 1966 appears as Peter Galassi, the curator of the MoMA show, is recounting the history of art photography's relation to the family. Discussing the work of Emmet Gowin, Galassi writes: "In about 1966 Gowin . . . discovered snapshot intimacy as a potent artistic theme."[2] With its opening date and its verb "discovered," this sentence suggests an inaugural moment, a historic beginning.

Although Gowin was shooting with a cumbersome, anything-but-casual, large-format camera, Galassi here refers to snapshots. A volume called *The Snapshot* published by Aperture in 1974 opens with the photos Gowin made of his family between 1966 and 1970—the volume can serve as a monument to the moment art photography turned to the snapshot. While some art photographers were experimenting with the sort of cameras that made snapshots, Gowin was exploring the subject matter of snapshots, family life.[3] This is what Galassi means by "snapshot intimacy": "To Gowin's subjects he is not the photographer but Emmet. . . . What he discovered is that the essential power of the snapshot lies . . . in the relationship between photographer and photographed."[4]

Galassi here uses the verb "discover" again; in fact, his single-paragraph discussion of Gowin uses the word "discover" three times, thus laying emphasis on the bold newness of what Gowin did "in about 1966." This image of "discovery" is amplified by a phrase Galassi uses two pages later to characterize the subject matter of the MoMA show: "The *terra incognita* of the domestic scene." It is only within the particular history of art photography that one could imagine the strange, even oxymoronic status of the home as uncharted territory.

What could be more familiar than the domestic scene? What photography

could be more familiar than the snapshot? Why did what was most familiar have to be "discovered" in 1966?

In a survey of the state of photography, published just one year earlier, in 1965, family photography and art photography stand as two diametrically opposed poles, and a photography like Emmet Gowin's, a photography that is somehow both art and family photography, is literally inconceivable.

This 1965 survey, *Photography: A Middle-Brow Art* by sociologist Pierre Bourdieu, is a comprehensive study of the practice of photography, ranging from family snaps to high-art photography, with analyses of photojournalism and advertising photography along the way.[5] Bourdieu's book is a portrait of photography captured live in a bygone moment, in around 1965. Like a photograph, the book describes what it finds as if it were true for all time, but our sense of what has happened since allows us to value it as an image of a moment no longer with us; our vantage point gives this panoramic and finely detailed image historical value. Bourdieu's survey is like a map of the photographic world as it existed on the eve of art photography's voyage into the terra incognita of the family snapshot.

This chapter will of course be taking Dick as its example of the larger trend of photographers making art in and of their families. Reading Bourdieu's *Photography* along with Dick's photography allows us to understand more fully the stakes of his hybrid practice of family art photography. One might object that Bourdieu's study is of photography in France while Dick (like Gowin and all the photographers collected by Galassi) lives in the United States, yet my sense is that this makes little difference for the issues considered here. Whether it is because France and America belong to the same art world in the late twentieth century, or for some broader sociologi-

cal reasons, I'm not sure. (That Dick himself happened to spend 1965 in Paris a few years before he picked up the camera is, I know, completely coincidental and irrelevant.) Whatever the reason, I am convinced that the analysis Bourdieu gives of photography in France in 1965 holds largely true for photography in the United States at the same moment.

By the early 1960s, in France as in the United States, the practice of photography is extremely widespread, easy, inexpensive, and available to almost anyone. At the same time, in both countries, there is a long tradition of art photography, a tradition attempting to claim its place as a legitimate fine art, like painting. This contrast between photography's common mass use and its high-art claims provides the central dramatic tension in Bourdieu's *Photography: A Middle-Brow Art.*

In the book's introduction, Bourdieu writes: "Nothing is more directly opposed to the ordinary image of artistic creation than the activity of the amateur photographer" (5). This opposition could not be more pointed. Not just differentiated, but *opposed;* not just opposed but *directly* opposed; not just directly opposed but "*nothing* is *more* directly opposed," the absolute extreme of opposition. At one extreme we see "artistic creation," at the other "the activity of the amateur photographer." Bourdieu's is a high-contrast vision, a vision in black and white.

Bourdieu's extreme opposition takes on additional meaning when we read the sentence in context. The paragraph just preceding this stark statement of the opposition is where the book first speaks of photography. When, after five pages of sociological methodology, Bourdieu finally broaches the subject of photography, he begins thus: "One might say of photography what Hegel said of philosophy: 'No other art or science is sub-

jected to this last degree of scorn, to the supposition that we are masters of it without ado.'"[6] Bourdieu's conception of the opposition between amateur photography and our image of art follows directly from his adaptation of this statement by Hegel (compare Hegel's "no other" and "to this last degree" with Bourdieu's "nothing is more directly opposed"). Recognizing Hegel as the model for Bourdieu's highly polarized image of photography suggests what sort of opposition structures Bourdieu's vision. The seemingly gratuitous invocation of Hegel suggests that in "nothing is more directly opposed" we may be dealing with a dialectical opposition: thesis, antithesis. And that might imply—although Bourdieu never goes there—the historical need for a synthesis.

The Hegelian description of a moment always implies change on the horizon. Hegel conceptualizes history as a series of moments: each moment is characterized by an extreme binary opposition; the tension produced by that opposition necessarily results in a new configuration. The implicit Hegelianism of Bourdieu's description might thus carry with it a latent promise of change.

Bourdieu's Hegelian frame suggests that the extreme opposition between art and amateur photography around 1965 might just be the contradiction that will produce a dialectical sublation in the next moment. This is in fact what happens, around 1966, when art photography discovers the snapshot. It is as if Bourdieu describes the historical moment so well, with such Hegelian sensitivity to the moment's dynamic contradictions, that his portrait can produce a sense of the necessity of the next moment, even if he does not see it coming.[7]

Although Bourdieu first poses the opposition between art and amateur

photography in static terms ("nothing is more directly opposed"), as his account continues the opposition becomes more dynamic, sounding more and more like a struggle. No longer merely an opposition between two concepts, it becomes an opposition between two groups of people. Just a few pages after the book's first formulation of the opposition, we read: "Aesthetes . . . attempt to liberate photographic practice from the social functions to which the great majority subordinates them" (8). The opposition between the "aesthetes" and "the great majority" is figured as a certain sort of political struggle: aesthetes want to "liberate" photography, to free it from its subordination.

Bourdieu's "aesthetes" are here trying to liberate photography from unspecified "social functions." The next time they appear, "the social functions" are specified: "Apart from a tiny minority of aesthetes, photographers see the recording of family life as the primary function of photography" (30). In this sentence "aesthetes" are contrasted with "photographers"—the latter word is unmodified, implying photographers in general, all photographers (if we do not count the negligible minority). Photographers (at least "the great majority") believe "the primary function" of photography is to record family life; that is the "social function" that the aesthetes oppose.

In contrast to "the great majority," aesthetes are "a tiny minority." "Tiny minority" seems dismissive: this viewpoint is so marginal, belongs to so few people, we shouldn't need to worry about it. "Aesthete" also seems derogatory, dismissive. Although it can simply mean "one who cultivates a superior appreciation of the beautiful," that meaning is shadowed by a second: "An effete person: one whose pursuit and admiration of beauty is thought to be excessive or affected."[8] A viewpoint belonging only to a tiny minority of ef-

fete people might be thought easy to ignore. But in fact that viewpoint, the view of photography as an art, is central to Bourdieu's book where the opposition between the tiny minority and the great majority—between photography as art and as social function—is what structures the meaning of photography.

In Bourdieu's account the aesthetes do not just have a different view of photography's function; they actively resist the familial function. The minority assert their aesthetic in and through their resistance to family photography. Later in the first chapter, writing about "the ardent practice of photography," Bourdieu says that its "aesthetic credo is often limited . . . to the refusal of family photographs. . . . In fact, the dedicated photographer always finds a minimal definition of his ambitions in the refusal of the ritual objects of ordinary photography. . . . the rejection of the family photograph, if it does not actually refuse the family all value, at least amounts to a refusal of one of the family values by refusing to serve the family cult" (40).

Five times in this short passage, Bourdieu uses the word "refusal." Although the dedicated photographer may do something besides refuse, he is "*often* limited" to nothing more and "*always* finds a minimal definition of his ambition" in "refusal." While recognizing that there can be more to "the ardent practice of photography," Bourdieu nonetheless reduces it to its lowest common denominator, refusal, and thus casts it as an essentially negative act.

Some twenty pages later, Bourdieu casts the aesthetic of the dedicated photographer as "purely negative": "Because its determinations are purely negative, the apophatic aesthetic of the devotees is still determined . . . by the 'popular aesthetic' which it denies" (64). The rare theological word "apophatic" reinforces this sense of negativity. From the Greek for "negative,"

"apophatic" is an adjective "applied to knowledge of God obtained by way of negation," "according to which God is known by negating concepts that might be applied to him."[9] As a "refusal," the apophatic aesthetic is "determined" by what it denies. Although this aesthetic might want to "liberate" photography, it is in Bourdieu's view itself far from free—it is in fact wholly "determined," reactive and derivative. The aesthetic of the devotees is not itself a thesis but only an anti-thesis.

Although Bourdieu's sentence certainly emphasizes the negativity and derivativeness of the devotees' aesthetic, something in the sentence might also suggest the opposite perspective. However negative it might be, the aesthetic of the devotees *is* an aesthetic; the word is not in quotation marks. What it opposes, the "popular aesthetic," is in Bourdieu an "aesthetic," in quotation marks.[10] The "popular aesthetic" here is precisely the belief that photography should be subordinated to its social functions, a belief opposed to the properly aesthetic point of view.[11] Bourdieu uses the word "aesthetic" for both the aesthete's and the majority's positions, which suggests that—contrary to the sentence's main thrust—something about the "popular" position is also derivative of the aesthetic position.

Before going on, there is one final thing I want to note about this sentence: Bourdieu says that the aesthetic of the devotees is "still" determined by its negation of the popular view of photography. That word is laden with the possibility of change. "Still" whispers that the antithesis (whichever way it may go, whichever term might be primary) might someday give way to another relation between the popular and the aesthetic view of photography.

Just a page earlier, Bourdieu, whether wittingly or not, does in fact give us

a glimpse of what that different relation might look like. "Even the most dedicated practitioners," he writes, "express the originality of their artistic intention by photographing different objects rather than photographing the same objects in a different way, refusing ritual functions rather than introducing new meanings into them" (63).

This is yet another rehearsal of Bourdieu's negative view of the dedicated practitioner. "Even the most dedicated": Bourdieu in this phrasing moves again toward the extreme in order to make his high-contrast point. Even the most dedicated express their originality through refusal, "refusing ritual functions." The dedicated photographer is stuck in reaction; his very "originality" can only be expressed in a derivative way.

Yet this particular rendition of the negative aesthetic includes an alternative. While even the most dedicated photographer is *still limited* to "refusing ritual functions," this sentence begins to imagine what else a photographer might do. The sentence ends with a striking contrast: while "refusing ritual functions" seems a purely negative act, "introducing new meanings" seems not only positive but hopeful. Here is true "originality," not derivative or reactive: introducing the new, the horizon of historical change.

Just before he imagines this alternative, Bourdieu asserts that "even the most dedicated practitioners" have not "acquired the generalized skill of adopting with regard to any object the aesthetic attitude." If they did acquire that skill, Bourdieu hints, if they could take the aesthetic attitude toward *any* object, photographers would then be able to make art not by "photographing different objects" but by "photographing the same objects in a different way." A photographer would then be able to adopt the aesthetic attitude toward the ritual objects of family photography.

138

Toward, for example, his children. That is of course what the fictional Edgar Rogers did with his daughter, starting in 1967, two years after Bourdieu imagined just such a possibility. While Kathryn Harrison's bleak view suggests that the aesthetic attitude wreaks havoc in and on the family, in this chapter I'd like to move beyond that sensational exposé, to consider some of the less violent effects of introducing a different way of looking at the ritual objects of the family cult.

Before I move to Dick's photos, I'd like briefly to look back at a photographer who predates Dick, Edgar Rogers, Emmet Gowin, and Pierre Bourdieu, a photographer who perhaps more than any other "acquired the generalized skill of adopting the aesthetic attitude with regard to any object," and who thereby taught it to the rest of us. An extremely well-recognized art photographer who, in the last decade, is coming to be rerecognized as one of the great precursors of family art photography—Edward Weston.

In his history of family art photography, Galassi cites Weston along with Emmet Gowin as the two photographers who bridge the gap between art and family snapshots.[12] He then devotes a paragraph to Gowin but says nothing more about Weston. In Anne Higonnet's 1998 history of the photography of children, *Pictures of Innocence,* Weston gets quite a bit more consideration than he does in Galassi's 1991 history: Higonnet devotes eight pages to Weston's 1925 photographs of his son Neil.[13]

Higonnet begins by reminding us that the photographs of Neil can be considered "a 'virtual icon of photographic modernism.'"[14] Photographic modernism may in fact be synonymous with what Bourdieu calls the generalized skill of adopting the aesthetic attitude toward *any* object. Some of Weston's best-known photos exemplify that. I'm thinking here, for example,

of his famous bell pepper: it is a lowly, familiar object, and the image is stunning precisely because the pepper has little intrinsic aura. Higonnet tells us that Weston, in his diary, "repeats with pride the Mexican muralist Diego Rivera's praise: 'Your work leaves me indifferent to subject matter.'"[15]

The Neil photos, viewed from this modernist perspective, achieve precisely what Bourdieu seems to be calling for.[16] Weston takes a classic object of family photography, his own son, and he makes art by adopting the same aesthetic attitude he directs onto any object. By photographing his son he is not "photographing different objects" than the majority of photographers; he is in fact "photographing the same object" as do millions of fathers, but "in a different way."

For decades, according to Higonnet, "art historians and critics followed Weston's consciously Modernist lead." To exemplify the modernist reception of the Neil photos, Higonnet quotes at length from an essay Nancy Newhall wrote in 1952: "In the torso of his little son Neil . . . sinuous shadows give life to delicate whites. In these . . . the beholder sometimes recognizes, with a tingle down his spine, the originals from which various centuries launched whole schools of thought. Here is a torso with the pure calm flow the Greeks took as ideal. The photograph is not Greek; it does not need to be. The reality it reveals existed before the Parthenon; it is continuous with man."[17]

Newhall's insistent reference to the Greeks invokes Greek sculpture without explicitly naming it. According to Bourdieu, photography constantly compares itself to painting in the attempt to claim the status of art. Newhall's move is bolder: black-and-white photography points to an older, even more consecrated art than painting, back to white marble. In a typi-

cally modernist way, the reference to Greece signifies both a specific tradition of sculpture and something "continuous with man." Carrying the ultimate Western art pedigree, classical sculpture can trump the more immediate rivalry with painting.

Weston's modernist photographs of his son Neil would seem to transcend both of the binds in which Bourdieu sees art photography caught. According to Bourdieu, art photography is trapped not only in a refusal of popular photography (as below it) but also in an envy of painting's legitimate art status (as above it). Caught between the popular family snap and high art, photography in its aspiration to be art can only be, says Bourdieu, "un art moyen," a middle art, a middling art. (*Un Art moyen*, the French title of Bourdieu's book on photography, is translated into the English subtitle, "A Middle-Brow Art.")

The Neil photos, however, seem neither to refuse family photography nor to envy painting. Rising above the very contradictions that for Bourdieu condemn photography to the status of middle-brow art, Weston's Neil photos might be said to realize Bourdieu's implicit (if impossible) ideal for art photography. If Weston—at least as understood within modernist art history—achieves Bourdieu's ideal, it may be because the sociologist is in fact operating with a modernist notion of art.

I began my reading of Bourdieu's *Photography* with his introductory assertion that "nothing is more directly opposed to the ordinary image of artistic creation than the activity of the amateur photographer" (5). In my earlier comments on this statement, I didn't mention the "ordinary image of artistic creation"; I would now propose that this "image" is in fact modernist. Writing in 1965 Bourdieu finds this image "ordinary"—that is, it is in the

air—and he presents it as for all time rather than as particular to the moment.

(That this might still be the "image of artistic creation" for many of us is no doubt due to the fact that, while cutting-edge artists and critics have progressed beyond modernism, its formations have been widely assimilated as the "ordinary" assumptions about art. Our "ordinary image" of art is still largely shaped by a modernism so successfully diffused as to be unrecognized.)

I began this chapter by saying that Bourdieu was, unbeknownst to him, writing on the eve of a new era in art photography. That era dawned when art photographers no longer imagined their project as "directly opposed" to the "activity of the amateur photographer," when they discovered instead the artistic potential of the snapshot. We might also want to describe that discovery as the moment of departure from photographic modernism.

Higonnet's reading of Weston's Neil photos starts with their modernist reception, but then it moves through their postmodernist reception (around 1980) and beyond, into what she calls "the perspective of the 1990s." It is the latter perspective that leads Higonnet to write: "After all, in one sense the *Neils* are family pictures, photographs by a father of his beloved son. . . . the *Neils* hover on the cusp between family snapshots and art photography." Higonnet then goes on to explore that cusp and flesh out the sense in which the *Neils* are "family pictures."[18]

She quotes from Weston's diary account of making the *Neils:* "Besides Neil's companionship . . . he afforded me a visual beauty which I recorded in a series of Graflex negatives of considerable value."[19] Weston here says he got two things from photographing his son. The second—to which the sentence

142

is largely devoted—is aesthetic, "visual beauty"; Weston sounds very much the dedicated photographer when he talks about "Graflex negatives of considerable value." But the sentence begins by remarking, if only in passing, that aesthetic value was not all Weston got from his son—he also got "Neil's companionship," the pleasure of his company. Edward Weston is able to say what Edgar Rogers never could, that he valued photographing his child not only because it allowed him to make art but also because he enjoyed doing something with him, enjoyed being with his child.

(This suggests that—*pace* Rivera—the "subject matter" of these photographs is in fact not "indifferent" to Weston, that he does not view his son as just *any* object. By going back and viewing these modernist icons from a perspective beyond modernism, Higonnet allows us to see that even within a project as explicitly modernist as Weston's there is in fact more going on than the modernist framing recognized.)[20]

Higonnet not only quotes from Weston's diary, she also reproduces a page from his "personal photograph album c.1925." Her discussion of Weston concludes with a comment on this album page: "On one page he happened to put pictures of Neil that do look like close snapshot relatives of his formal *Neils*."[21]

Rather than the diametric opposition Bourdieu supposes between art and family snaps, Higonnet finds a family resemblance. Juxtaposing Weston's consecrated icons of modernism with the family album, Higonnet finds that the snapshots "look like close relatives" of the "formal" pictures. Where Bourdieu polarizes terms, maximizes their difference, Higonnet here looks for and enjoys similarity, proximity, resemblance. Higonnet's metaphor bespeaks a familial gaze, as if she is looking at Weston's photographs

the way we look at family albums: part of the pleasure we get from the family album is seeing people "look like close relatives."

When Weston makes his "formal *Neils*," he brings the aesthetic attitude into the family. Seventy years later, Higonnet turns around and brings the familial gaze into the world of art, looking at art photography in a family way. The first move, although not mentioned by Bourdieu, is imaginable by him; the second move more radically alters the world of photography as Bourdieu knows it. That is in part what I'd like to consider here: how does art look when we bring it into the family, when we look at it with a familial gaze?

Let me start by considering a photo Dick took of Max around 1992. This photograph has always struck me as sculptural: perhaps first because it presents the classic head and shoulders of the sculptural bust, but probably most of all because for me the focal point is Max's radiant right ear, whose perfect form and dazzling whiteness seem made of marble. The marble ear, the exquisite long diagonal of the neck, the lovely curves, proportions, and smooth whiteness of Max's beauty all somehow evoke sculpture.

My idea that this photograph is sculptural cannot be separated from my pleasure in seeing my son look so beautiful. Although it might represent nothing more than the chutzpah of a mother's love, when I read Nancy Newhall's celebration of the Neil photos, I think of this photograph. There is something about the way the black-and-white photo makes the flesh look like marble. And probably there is also something "Greek" about the beauty of young boys.[22] (Although Max here is only six years old, the length of his neck, the cut of his hair, and his attitude bespeak not the cute "little boy," but the more dignified and more erotic "young boy.")

144

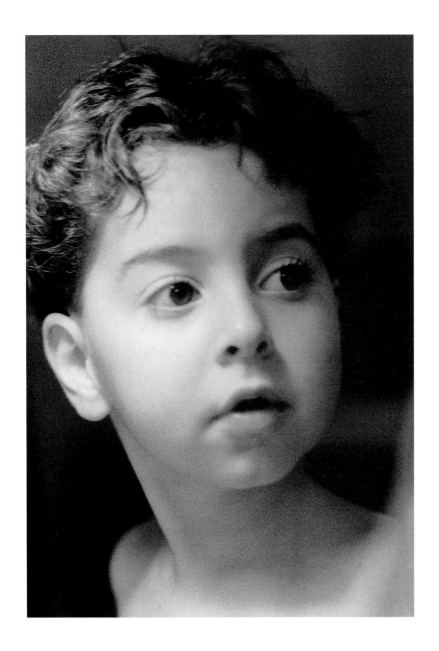

My pleasure as a mother is not at all in opposition to the aesthetic here. On the contrary, it is my sense that Max has become art that so gratifies me as his mother. And I think I read something like this mix of parental pride and aesthetic attitude in Weston's relation to Neil's "visual beauty": not only is Weston profiting as an artist from his son's beauty, but he is also getting surplus value from it as a father.

In his diary, Weston writes: "Besides Neil's companionship . . . he afforded me a visual beauty which I recorded in a series of Graflex negatives of considerable value. . . . When I return he may be spoiled, if not bodily changed, in mental attitude. Last spring . . . at eight years, he was in the flower of unawakened days before adolescence: tall for his years, delicately moulded, with reed-like flow of unbroken line: rare grey eyes, ingenuous, dreaming, and a crown of silken blond hair. He is a lovely child."[23]

This is very much the territory explored in the preceding chapter: the "flower of unawakened days before adolescence" and the "crown of silken blond hair" are the familiar attributes of the child we all want to catch in our emulsion. Like Lewis Carroll, J. M. Barrie, and Edgar Rogers, Weston wants to capture this flower before it wilts ("when I return he may be spoiled").

When earlier I quoted the first sentence from this diary passage, I remarked that it represented Weston's double relation to Neil, as a loving father and as a dedicated photographer. Looking at the continuation of the passage, these two roles are not so neatly separable. The detailed appreciation of Neil's "visual beauty" could express either the photographer's aesthetic attitude or the father's loving pride ("delicately moulded" sounds more the aesthete; "tall for his years" sounds like paternal pride to me). When we get to the conclusion—"He is a lovely child"—we would be hard put to know whether it is the photographer or the father speaking.[24]

146

Weston's blend of parental pride and aesthetic judgment suggests a very different relation than Bourdieu's diametrical opposition. One of the reasons parents take photographs of their children is to show how beautiful they are. Edward Weston can draw on all the resources of his finely cultivated sense of beauty to perform this function in a way that surpasses the powers of most fathers. The aesthete father can distinguish himself in the fulfilment of a social function, can gain real surplus value from combining parental and aesthetic discourse: "You think your kid's beautiful, well look at mine: he's a regular work of art!"

Let me show you another beautiful picture: this one's also my kid. The naked body here reminds me again of Greek sculpture. In this one the allusion is not to the smooth radiance of white marble but rather to the heroic tradition of the athletic body. Although this is in fact a little girl (Ruby is four years old in this photo), the body seems not delicate but powerful. Her back is broad; the curves are muscular. If the focal point of the previous photo is Max's ear; here it is Ruby's raised backbone. While an ear is open, attuned, in an essentially passive, receptive relation to the world, a backbone figures strength and resolve.

Hunkered down, solidly balanced and tightly coiled, Ruby's posture in this photo signifies concentration. Not arrayed for our gaze, this body is closed not open. This body is an agent concentrating on its own projects.

In contrast with the picture of Max, the most compelling parts of this body are not white but dark. The allure is not so much in the light on her flat, smooth back but in the more textured, contoured, shadowed parts of her body—backbone, legs, arms, shoulders, sides, and haunches. The haunches in particular might indicate what sort of body this is—or rather

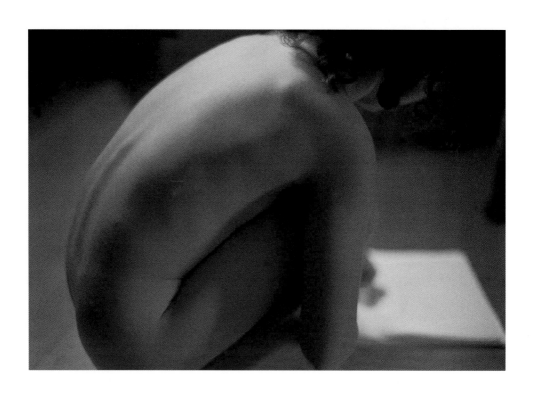

148

what sort of body it is not. The buttocks here are not the soft, white vulnerable flesh so often found in images of children.[25] Posture, camera angle, and lighting combine to present the buttocks as muscle, gluteus maximus—the seat of her strength and activity. The power in these haunches recalls the Greek tradition of the naked athlete.

That the lovely boy should be delicate and open while his sister is forceful and concentrated might launch reveries about gender-crossing—reveries that thread through the classical tradition of the lovely young boy. But the boy's powerful sister crosses gender in a direction that does not lead back to Greece.

The strong, athletic little body is crowned with ringlets, those curls that can signify both angelic innocent child and female sexuality. The body and the hair figure a contrast and together give us an image of a new kind of girl. We have here not a classical androgynous image (as in the photo of her brother) but a new hybrid. Those muscles and ringlets belong to our era of the female athlete, our very recent eroticization of muscular femininity.

This image of Ruby refers not only to gender but also to art. In her naked beauty, she definitely figures as a work of art. But she is not only a sculpture for her father's camera. The out-of-focus white rectangle in the bottom right corner of the picture is the paper on which she is drawing. That determined, muscular body is making art.

This photograph reminds us that it is not in fact up to the artist-father to introduce art into the family. Art is in fact already there. Even at her age, Ruby has learned to call drawing "art." It is a category of activity at the daycare center (although photography is not in that category). This sort of art, the sort that so regularly adorns refrigerators, is in fact the most com-

mon form in which "art" appears in the family.[26] The white paper on which Ruby draws echoes the light on her back: the photograph proposes a relation between the two, the aesthetic gaze of the father who sees his daughter as a sculpture and the daughter's own art making.

This is in fact a portrait of the little girl as an artist. Its muscularity can be seen as a celebration of the artist's power and activity, a sort of portrait of the artist as hero. This heroic aspect is more explicit in the last photo in the previous chapter—Max drawing in the sand. In the boy with the large stick, marking and claiming the shore on which he has landed, we can see art as conquest, the artist as conquering hero.

Of course the artists in these portraits are *little* heroes, children. The photos draw on heroic tradition in the way that children play at being heroes, with the complete seriousness of children, viewed however from the perspective of an appreciative but no less adult gaze. What is heroic here is not the accomplishment but the ambition, the resolve, the force in Ruby's absolute concentration. As the father-artist looks at his daughter drawing here, what he appreciates is not the art itself—which is literally out of focus. What he appreciates *and identifies with* is the intent to make art, the artist's desire. The portrait of the little girl as an artist is also a portrait of the artist as a little girl.

Dick has in fact made quite a few pictures of children drawing. Here, for example, is another. The artist in this one is not exactly heroic but we nonetheless see intensity, resolve, and drive. Max here is like a caricature of the tormented artist.

Although but a few years older than in the marble bust photograph, Max looks very different. In fact that classic right ear is still there but now looks

overlarge, out of proportion, and ugly. His skin is grainy and mottled rather than smooth and white; that beautiful smooth nose is here wrinkled and misshapen; instead of the perfect lips, we see teeth.

Max is angry in this picture, graphically so. On the table in front of him is the drawing he has just made. Like his face, the drawing expresses his anger.

I am struck by the resemblance between the drawing and Max's face, not only as expressions of his anger but even in their formal detail: the paper shows a vertical group of lines that echo the front of his hair, separated into lines by his hand, and below the drawing's vertical fringe are two strong horizontal lines, somehow like his eyebrows. The single line running down and curving off the paper uncannily mirrors the dark crease that runs from the side of Max's nose down to the edge of his face.

The resemblance between Max's face and his drawing makes the latter a sort of abstract self-portrait. The photograph then duplicates Max's gesture: first Max then Dick make portraits of Max angry. The photograph however portrays both Max's anger and his drawing; it is a double portrait, an image of Max's affect and his artistry, an image of the relation between his art and his anger.

To think about the relation between art and anger portrayed here, it may be useful to consider the dynamics of the scene of this drawing. Max got angry at Dick and me because we refused to give him something he wanted. (I'm afraid I don't remember what the specific wish denied was—to eat something? to buy something? to go somewhere?) He sat there across the table from us, frustrated and angry. And he wanted to make sure we knew how angry he was. The drawing is literally between Max and us. Not only is it on the table between us but it also expresses his distance from us and speaks his distance to us.

At this age, when Max got angry, he frequently made his face into the sort of mask of anger we see in this photo. The expression looks exaggerated, like a theatrical mask, because Max is not just feeling angry but wants to show his anger, to perform it for our gaze, to make sure we get it. The drawing functions like the dramatic face he makes. It is addressed to us, an expression of his anger whose purpose is to show us how he feels. Not just an expression—not just a means of getting it out, letting off steam—the drawing is a communication of anger.

I find this photograph compelling. Perhaps because it corresponds to some "ordinary image of artistic creation." I borrow this last phrase from Bourdieu to evoke my sense of recognizing in this photo an image of the tormented artist that circulates in our culture. When earlier I discussed Bourdieu's use of "the ordinary image of artistic creation," I identified him as having a modernist image of the artist. The image I recognize in this photo is a different image of the artist, more romantic than modernist, but I think it is likewise in the air. And I think it might in fact correspond to an image of the artist we can also find in Bourdieu's book.

In *Un Art moyen* we find the statement that "every exercise of the imagination is in its way a revenge."[27] This remark is part of an observation about art in general; its main point is that art—like any "exercise of the imagination"—compensates for what reality denies us. But the word "revenge" suggests that the anger that this photograph of Max displays might play a widespread role in the motivation of art.

This statement appears in the conclusion to *Un Art moyen*, a conclusion that was written not by Bourdieu but by Robert Castel, a member of Bourdieu's research team.[28] Whereas the rest of the book is a sociological account of photography, the conclusion is a psychoanalytic account. (In a

brief preface to the conclusion, Bourdieu says he hopes to demonstrate "the complementarity of sociology and psychoanalysis.")[29] As a psychoanalytic account, the conclusion necessarily understands the artist in terms of his infantile motivations. Thus, like the photographs we are considering, Castel is giving us a portrait of the artist as a child.

Castel's psychoanalytic conclusion is not included in the English translation, published twenty-five years after the original French edition of *Un Art moyen*.[30] This image of the vengeful artist in Bourdieu's book is thus not only infantile but belongs to an earlier stage of the book and has since—we might say—fallen victim to repression. If I nonetheless cite it here, it is because I believe that even in the properly sociological parts of the book, even in those sections penned by Bourdieu himself, there remains an image of the artist that bears a family resemblance to Max drawing in anger. Bourdieu's sociological portrait of the artist in the family is, to be sure, less dramatic than either Castel's psychoanalytic account or Dick's picture of Max. Yet it is not without its affinity to Max facing his parents and putting his art between him and us.

In Bourdieu's *Photography,* who has aesthetic aspirations? Who wants to make art? Bourdieu answers that question sociologically: "Aspiration to a practice directed towards aesthetic ends is not . . . the property of the most cultivated individuals . . . rather it is encountered among those who share the lowest level of integration into society, either by reason of their age, their matrimonial status or their profession" (39).

We might suppose that aesthetic aspiration would be the property of "the most cultivated individuals," those with the highest level of culture. What Bourdieu ascertains, however, is that the desire to make art photography is

found not among the highest but among the "lowest"—in individuals who have "the lowest level of integration into society." (Bourdieu's depiction, once again, goes for the extremes.)

The aspects of integration are delineated in recognizably sociological categories—age, marital status, profession. Although the book does not make clear what "professions" embody "the lowest level" of integration, it does specify that it is young people and single people who are the least integrated. And it is this social status of least integration that is more likely than any other to determine whether an individual will want to make art with his camera.

Although in this quotation it may appear as a typical sociological abstraction, "integration" is in fact a central concept in Bourdieu's theorization of photography. The first section of the book's first chapter is entitled "Photographic Practice as an Index and an Instrument of Integration." Index and instrument, photography is both a sign of integration and a means of integration, both effect and cause. As a double tie, this relation knots photography and integration more tightly together.

Photography's table of contents includes a one-sentence summary of each section. The summary of the "index and instrument" section plays on the double relation: "Photographic practice is a function of the integration of the family while also having a function of integration as a rite of solemnization" (vi). Photography both *is* a function of integration and *has* a function of integration. While the double meaning of "function of integration" tightens the knot, making this sentence quite difficult to follow, we can remark that the abstract "integration" of the title has become "integration of the family."

Later in the book, Bourdieu repeats the double formula, declaring that

"family photography is both an index and an instrument of integration" (40). The photographic practice doubly tied to integration is here specified as "family photography." Family photography both *shows* and *makes* integration, has as its purpose to further integration by showing integration. The social integration at stake in photography is in fact integration in and of the family.

That this idea of familial integration turns out to be central to Bourdieu's findings on photography can perhaps best be seen in a statement made in the very last paragraph of the book, the final paragraph of the appendix. (Like the conclusion, the appendix does not appear in the English translation.) The appendix reproduces for the reader the actual questionnaire used to gather the material for this sociological survey of photography. Placed right after the questionnaire, the last paragraph sounds a note of regret: "The results this questionnaire allowed us to obtain make us regret that it did not include a set of questions allowing us to measure in a more precise fashion the surveyed subject's integration into a family and the degree of integration of that family."[31]

This statement is singular. No other such regret, no other dissatisfaction with the survey, is expressed. The original French edition of *Un Art moyen* ends on this note of regret: if only we had known . . . if we knew then what we know now. . . .

Bourdieu did not foresee that familial integration was going to be such an important factor; he only realized its importance after completing his study. What we have here is truly a discovery—something the research found that it was not expecting, not looking for. The singularity of this statement of regret suggests that this link between photography and familial integration is in fact *the* find of Bourdieu's research on photography.

Not only is integration cause and effect of photography, it is also photography's content. "In most group photographs," writes Bourdieu, "subjects are shown pressed against one another, often with their arms around one another. . . . The convergence of looks and the arrangement of individuals objectively testifies to the cohesion of the group" (81). Integration, cohesion, is the image sought: "It is the group as such that the photograph ought to capture" (82).

In *Photography,* "the group as such" is predominantly the family. The section "Photographic Practice as an Index and an Instrument of Integration" ends with a consideration of the family album: "There is nothing more decent, reassuring and edifying than a family album; all the unique experiences that give the individual memory the particularity of a secret are banished from it" (31).

The family album testifies to the cohesion of the family, gives an image of the family as such. In order to achieve that group image, the "unique," the "individual," the "particular" must be banished. Nothing is left but the common life of the family, what the family members have in common—what Bourdieu later in this same passage calls "the common past, or, perhaps the highest common denominator of the past" (31).

The last phrase is striking. In place of the usual "lowest common denominator," we find the "highest." The substitution reminds me of the passage where Bourdieu finds "the lowest" instead of the "most cultivated" individuals. Whereas we expect art to be associated with the highest, it turns out to belong with the lowest. And vice versa. The "common" is here associated not with the lowest but with the highest ("there is nothing more edifying").

In the consecration of the "common," which for Bourdieu is the very purpose of family photography, anything particular, unique, individual is "ban-

ished." The cost of the image of "the group as such" is the radical exclusion of individual experience. Thus banished, individual experience becomes a threat to family unity, a threat to decency ("there is nothing more decent, reassuring than a family album").

A sentence before he declares that there is nothing more decent, Bourdieu says of the family album: "There is nothing more unlike the introspective 'search for lost time'" (30). The repetition of "nothing more" locates us in Bourdieu's polarized structure. The family album is located at the extreme of decency and edification, at the high end; at the other extreme ("nothing more unlike") we find "the introspective 'search for lost time.'"

The last phrase is in quotation marks to signal what in the original French is an unmarked literary allusion, the use of the phrase "la recherche du temps perdu" from Proust's novel title *A la recherche du temps perdu* (translated as *Remembrance of Things Past*).[32] Bourdieu can assume that his French readers will recognize the phrase and know that he is placing Proust's modernist masterpiece of "individual memory" in opposition to the family album. What is banished from the edifying family album is what we find in Proust—"the unique experiences that give the individual memory the particularity of a secret."

Citing Proust's familiar title phrase, Bourdieu interpolates an adjective: "La recherche autistique du temps perdu."[33] In place of this striking adjective, the English translation offers "introspective" which—although surely something one might associate with Proust's narrative—does not carry the pathological charge of Bourdieu's *autistique* (austistic). By inserting that word into the Proustian allusion, Bourdieu rapidly transports us from the level of "the most cultivated individuals" (Proust, his characters, his readers) down to "the lowest level of integration into society."

When I first read *Un Art moyen,* I was in fact so surprised by the adjective *autistique* that I wondered if it were not a typographical error for *artistique,* an adjective I would expect in the context of an allusion to Proust. Although I have no reason to believe this is a typo, I think there might nonetheless be some connection between our "ordinary image of artistic" and what Bourdieu here calls "autistic."

Bourdieu went into his research on photography presuming, like the rest of us, that aesthetic aspiration would be the property of "the most cultivated individuals." What he found, much to his surprise, is that in photography the desire to make art is linked to "the lowest level of integration in society." Whereas I would not apply this extreme description to most photographers—not even to Bourdieu's exemplary "fanatic who has to be asked to take a photograph of the children when he spends hours in the secrecy of his darkroom" (40)—"the lowest level" of social integration seems quite appropriate to describe the autistic individual.

In *Photography*'s view, art photography is, let us remember, the diametric opposite of family photography, defined indeed by its refusal of family photography. "Without seeking to take the symmetry too far," writes Bourdieu, "it is clear that if family photography is both an index and an instrument of integration, a photography defined by its rejection of the family function often reveals the lowest level of integration into the family group . . . while also often having the effect of reinforcing this low level of integration by expressing it" (40).

Like family photography, the photography "defined by its rejection of the family function" also has a double relation to integration. Photography with aesthetic aspiration can be both effect and cause of a lack of integration. Bourdieu understands art photography *in* its relation to the family, as an

159

expression of a negative relation to the family: it "reveals" a lack of integration into the family group.

For Bourdieu, art photography "reveals" this sociologically, reveals it to the sociologist in his survey of photography. But if we consider the possibility—which Bourdieu does not imagine—of art photography *in* the family, of the photographer directing his aesthetic gaze onto the family group, then the lack of integration of that group might be "revealed" not only sociologically but photographically. The lack of familial cohesion could become not only cause and effect but also *content* of the photography.

Where family photography shows "the group as such" (the convergence of looks and the arrangement of individuals testifying to the group's unity), art photography might show the lack of cohesion in the family group, might show the very individual experience banished from the family album because it threatens the reassuring cohesion of the family group.

Take, for example, this picture of me and the kids, a month or two after Ruby was born. It is a photograph of an absolutely classic family "group" (Mom and the kids photographed by Dad), but rather than display cohesion it reveals trouble. The arrival of a new baby is a typical moment for family photos: a picture is taken in order precisely to *integrate* the new arrival into the group. In such a moment the proper role of included older siblings is to share in the common joy, not to reveal their private pain at being displaced in their mother's affections.

The three of us are indeed physically cohesive; we are one composite mass against the scenic background. Often appearing in sculptures of mothers with their children, this composite mass is a way to signify maternity: the children look like literal outgrowths of my body. Yet our bodily unification

160

only serves to underscore the ideal this photograph refers to and belies. Our bodies may be conjoined, but our looks are far from convergent. The pain on Max's face is all the more poignant because I do not see it. This is a photograph taken behind the mother's back, revealing what the mother doesn't see—and in the process suggesting what might be hidden behind all those pictures of mothers surrounded by their children.

Ruby is up and Max is down; Ruby is in the foreground while Max is farther back. His mother's only child until the age of nine, Max suddenly finds someone else in her arms. That Ruby does not yet look worthy of replacing him—doesn't even know enough to enjoy her triumph, taking her place in her mother's arms so very much for granted—makes his exclusion all the more poignant.

Max looks right at the camera, silently appealing to his father to do something, to remedy this unbearable situation. Although the photograph cannot put Max back in his mother's arms, it does in fact wreak a certain "revenge." The photo takes Max's side—he is the more compelling, the more beautiful, the one who engages the camera. While the baby may have the place in mother's arms, Max here has the place of honor in father's aesthetic gaze. This photograph loves Max more.

Through the symmetry Bourdieu teaches us to appreciate, this art photograph functions like a reversal of the standard family photo. A reversal, first, by being shot as if from behind, but also a reversal in that, rather than confirm the family value of subordinating individual to group, this photograph gives its love to the individual who suffers from the demand for integration. If the cohesion of family life demands that Max must cede his mother's arms, his father's gaze introduces another regime—a counter

order, an order that can exact a certain revenge for the denial of Max's wishes, an aesthetic order in which Max's pain takes on great power.

Not a picture for the family album, this photograph portrays a more Proustian subject. Max here recalls little Marcel alone in his bed pining for his mother. Beginning with the little boy, Proust's gorgeous novel relentlessly portrays the pangs and injustices of jealousy, the way jealousy makes individual experience secret. (Max's feelings are secret here because behind his mother's back.) In the photo's triangle of bodies we can recognize the geometry of all rivalry, the jealousy that is Proust's subject par excellence.

While Proust explored the insistent geometry of jealousy, he never explicitly addressed the particular triangle we see here: two siblings vying for mother's love and attention. Ruby's arrival in our household brought not only a new persona but a new drama for Dick's camera. Beginning with this photograph, sibling rivalry grew into a major theme for Dick's photography, the subject of a burgeoning series of pictures.

Here's one taken a few years later: the triangular structure is the same but the kids have switched places. In this one, Max is both higher and more in the foreground than Ruby. Now, Ruby is behind my back.

Concentrating on the task of lighting Max's candles, I am oblivious to Ruby behind me. She is no longer a baby and, what's more, it's Max's birthday, which entitles him to the sort of premium attention that babies get. While Max basks in the glow of maternal attention, Ruby peers out from behind my elbow, watching with a bitter, vigilant, resentful eye.

The former picture is tragic; this one is comic. The genre difference may reflect the difference in seriousness between a birth and a birthday party, the latter a lighthearted commemoration of the former. Whereas Max had to

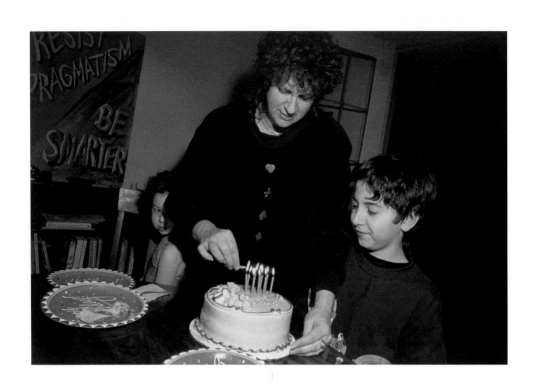

164

suffer a historic change in status upon Ruby's birth, a permanent loss, Ruby here has only to put up with a momentary subordination to Max, the way this anniversary of his birth allows him to be baby for a day. Max's suffering in the last picture is serious (Dick told me he had a hard time printing that photo, not for technical reasons but because he found it difficult to look at Max's pain). Ruby's unhappiness here is comic because we know it's temporary, because we can put it in perspective even if she can't. While Max will never regain that unchallenged place in his mother's arms, Ruby will in fact have her turn to be the birthday girl.

The genre difference between these two pictures might also reflect a genre difference in the traditional family photos to which they refer. Like the new baby, the birthday party is a stock moment for family photography. Yearly birthday party snaps are, however, much more casual family photos than the solemn photographic presentation of the new arrival in birth announcements.

Despite its merry tone, the standard birthday party shot nonetheless performs a serious function: a ritual moment of family life, the party serves the album's image of the happy, cohesive family. The party celebrates the individual as part of the group: while the "birthday boy" is allowed his self-centered place as individual, the rest of the family is supposed to gather in an undifferentiated mass to constitute the group as such. Ruby here refuses to blend into the communal background; she begrudges Max even one day as center of attention. In its resistance to the obligatory commonality, her individual experience of this event becomes secretive.

While in the previous photo Max looks directly at Dick, engaging and appealing to him, here Dick catches Ruby in the act of her selfishness. Her

obliviousness to the camera, caused by her complete focus on Max and me, are part of what make Ruby comic. She doesn't ask us to care about her, and our response—in real contrast with our response to Max's naked pain in the preceding shot—is detached amusement.

The comic tone includes the poster on the wall in the far left of the photo, with its joke slogan "Resist Pragmatism/Be Smarter." That poster was a prop in an avant-garde performance, a mock political demonstration. It's on the wall in our dining room because the slogan carries something of our family sense of humor. In our family, part of the joke is that we all tend to be so "smart" that we're often impractical, refusing to bend to the common sense that might make life easier. Although Ruby can't read and wouldn't understand the word "pragmatism," she seems to heed the poster's radically idealist message by refusing to compromise, refusing to do the reasonable, practical thing, which would be to accept the reality of the situation. The poster becomes a sort of Barbara Krugeresque caption in this photo. And its militant if ironic tone is definitely on Ruby's side of the picture.

On the other side, Max and I are in a classic, unironic family photo. He beams in the warm, kitschy light of the birthday candles, and I play my maternal, supporting role in all seriousness, with complete concentration. My body, taking up the center of the photo, divides the two sides: in front of me is the festive, happy family; behind me is the disaffected individual and the ironic commentary.

Although the tone here differs from the earlier picture, the two definitely share a structure. In both cases, secret individual experience is literally behind the mother's back. What mother does not see and father's camera captures is precisely what, according to Bourdieu, is meant to be banished from

the family album. The drama in these photos is in part about the disparity between what mother sees and what father sees.

Bourdieu, it turns out, also finds a dramatic split between father's and mother's vision in households where the father is serious about photography (i.e., households like ours):

> Many enthusiastic amateurs . . . stress the sexual division of photographic tasks and interests, and jealously keep for themselves the more noble uses of the camera, leaving their wives with the traditional uses to which their "femininity" has "predestined" them. . . the ardent practice of photography—whose aesthetic credo is often limited . . . to the refusal of family photography—by its very nature demands a complementary practice, which is left to the wife and entirely devoted to family functions. (40)

We can recognize here the opposition between family and art photography so central to Bourdieu's view. But in this instance that binary opposition is also mapped onto the gender binary. With his scare quotes, Bourdieu is, to be sure, careful to distance himself from the sexist presumptions of his survey subjects. His own preference for diametric opposition nonetheless leads to a familiarly polarized image of the "sexual division" ("by its very nature demands a complementary"). Men are on the side of the noble and the aesthetic; women are on the side of a photography "entirely devoted [like a good wife and mother] to family functions."

Although I don't much like the sexist stereotypes, I must confess to recognizing myself in this portrait of the division of photographic labor in the home of the serious photographer. When Max was born, I bought myself a

cheap little Kodak camera. I felt the need to supplement Dick's black-and-white art photographs with color snapshots that I could use to show people how adorable the baby was. For the first few years of Max's life, I took pictures, only of Max, all of Max looking cute. I wanted something I could not get from Dick's photography, even though Dick was taking hundreds of pictures of Max.

Whenever I wrote to someone living in a different city, I included a picture of Max. I carried snapshots with me, especially when I traveled out of town, showing them to people who could not see the baby in person. Reading Bourdieu I discover that not only was I making traditional photographs for traditional purposes but in so doing I was also playing a traditional feminine role:

> The sexual division of labour gives the wife the responsibility of maintaining relations with the members of the group who live a long way away. . . . Like letters, and better than letters, the photograph has its role to play in the continual updating of the exchange of family information. . . . It is customary to take the children to the relations who live outside the village It is the wife who organizes these trips. . . . The sending of photographs has the same function: by means of photographs, the new arrival is introduced to the group as a whole, which must "recognize" the child. (22)

In sending snapshots of my son to friends and colleagues around the country, I was trying to integrate him into my group. My "group," however, was not familial but professional—the people to whom I showed and sent these photos were academic colleagues, English and French professors

around the country. Pursuing social integration into my profession, I was, it seems, acting very much like a traditional wife.[34]

Indeed, like the most traditional of wives. The Bourdieu passage just quoted is about the most traditional group he studies, rural peasants. In fact, it is from the study of photography in the lives of these peasants that Bourdieu derives his understanding of traditional—i.e., family—photography. At the furthest remove from art photography, these families nonetheless in one regard resemble the households of "enthusiastic," "ardent" photographers. Located at opposite poles of Bourdieu's spectrum, the rural peasants and the families of photographers with aesthetic ambition both manifest a sexual division of labor that assigns family photography to the wife/mother.

Before I go on, I want to note something a bit odd about the passage quoted in the extract above. Photography and the wife never appear in the same sentence. Bourdieu does not say that photography is the wife's responsibility; nor does he say she sends the photographs; he says it is her responsibility to maintain long-distance group relations. The association between the wife and photography is diffuse, mediated, not literal. Whether or not she takes or even sends the photographs, family photography and its function of integrating the group belong—symbolically if not literally—on the side of the mother.

Although Bourdieu says "wife," I say "mother" because the passage about the sexual division of labor in peasant families is not about family photographs in general but specifically about photographs of children. Not only does "mother" jibe better with my own experience of taking up this role at the moment I became a mother, but it resonates with a certain role the

mother plays in Bourdieu's *Photography,* a role neither systematic nor theorized, a sort of cameo role.

At several points in the text, Bourdieu speaks in fact not of women or wives but of "mothers." I'd like to look briefly at those passages in order to glean a sense of the mother's place in *Photography.*

In the section on the most traditional photography, Bourdieu writes: "The first communion provides many mothers with an opportunity to have their children photographed" (21). A paragraph later he states: "The mother who has her children photographed can only meet with approval" (21). Both of these sentences put the mother in the same relation to photography: she does not hold the camera but is the one who wants the photographs. It is worth noting that it is not "parents" but "mothers" who "have their children photographed." If traditional photography serves the family, it is in fact the mother who somehow speaks for the family, who enjoins in the name of integration.

This lends an interesting psychological coloration to the photographer who "refuses" to serve the family, to subordinate his aesthetic to "the family cult." In the traditional family, the camera may be "his," but it serves her. When "he" becomes a serious photographer, he refuses to devote his camera to her wishes, which then makes it necessary for her to pick up the camera. The ambition to make art might thus, in Bourdieu's view, be opposed to the mother's desire that photography serve the family.

Sociology, on the other hand, turns out to be very much on the mother's side:

> It is natural that photography should be the object of a reading that may be called sociological, and that it should never be considered in and for itself, in terms of its technical or aesthetic qualities. . . . the read-

ing of old marriage photographs often takes the form of a course in genealogical science, in which the mother, a specialist in the subject, teaches the child about the connections which bind him or her to each of the people shown. . . . she analyzes and compares the sphere of social connections. . . . In short, the wedding photograph is a real sociogram, and it is read as such. (23)

In this passage taken from Bourdieu's portrait of the most traditional families, the mother is not only the mistress of family photography, she is a figure for the sociologist.

In this passage, the opposition is between photography "considered in and for itself" (the aesthetic view) and the sociological reading of photography. This opposition between the aesthetic and the sociological view may well be the fundamental form of the opposition that structures Bourdieu's *Photography*. This is a self-reflexive moment of the book, a version of the structuring opposition that explicitly includes the book's project, an argument for a "sociological reading" of photography.[35] And in the warm light of this passage, Bourdieu gives us a figure for sociological reading, inscribing the book's project under the sign of the mother.

Teacher, specialist, analyst, scientist: the language of the passage elevates this mother to Bourdieu's professional status.[36] But ultimately it is she who elevates him: this figure lends an aura of authenticity and devotion to his endeavor. This peasant mother is like the matron saint of the sociological reading of photography.

While this mother exemplifies the traditional function of photography, another mother can be glimpsed in Bourdieu's *Photography*, this one not so exemplary:

> If the picture in which the members of the family seem distracted . . .
> provokes disapproval, it is because the weak cohesion of the family
> group is read into it. . . . "Well, it's a family. I don't like the mom, she
> looks miles away. She's a bit more of a mom in this one. All the same,
> though! She's a funny mother, with her dangling arms . . . This picture's
> horrible." (82; final ellipsis in Bourdieu)

Bourdieu is here quoting a survey subject (part of Bourdieu's survey in-
volved giving subjects photographs to look at and then registering their re-
sponses). Although Bourdieu gathered hundreds of responses to photo-
graphs, this is the one response he quotes to exemplify the demand for
group cohesion as the primary value in photography.

Bourdieu's own words in the passage make the theoretical point: distrac-
tion on the part of a family member is taken to represent weak family cohe-
sion. In the only example cited, the family member who is distracted hap-
pens to be the mother. The bad example, the "horrible picture," turns out to
be a photograph of a "funny mother," a mom who doesn't look quite
enough like a mom.

The two specifics cited are telling: when she "looks miles away" she is not
totally contained in the group; her "dangling" arms are like loose ends that
threaten to unravel the tightly knit cohesion desired from the family photo.
When, regarding the second photo of the same family, the subject says "she's
more of a mom in this one," it implies that looking "miles away" in the first
one makes her look less of a mom. But even in the second picture she's only
"a bit more" of a mom, still doesn't really look very much like a mom. In this
"horrible picture," the literal mother fails to symbolize the mother, and be-
cause family photography—and perhaps especially the mother—is meant

to be symbolic, this literal family fails to symbolize the family, to represent the group as group.

In contrast to Bourdieu's anonymous subject, I feel quite fond of, attached to, this "funny mother." In truth, I identify with her. Here, for example, is a photo of me as the mom who "looks miles away" (photo 24).

Although my arms may not be dangling—at least the one visible arm is wrapped around Ruby, holding her close—my face is slightly out of focus. Ruby is in sharp focus; as close as she is to me it's as if I'm at some distance from her. She has my body for comfort but not my attention: my thoughts are elsewhere. As if to symbolize the superficiality of what she can get, Ruby clutches at my nightgown. The nightgown's pattern suggests some sort of wild creature, captured but not fully domesticated, the body here but the mind still roaming miles away.

The mother who "looks miles away" is the very antithesis of the mother who sends photos of her children to relatives who live outside the village. Whereas the latter extends the family's reach, the former intrudes the outside world into the closed space of the family. One brings her maternal role with her wherever she goes (like me with my baby snaps at academic conferences); the other is not wholly in her maternal role even when she's with her children.

(It might be worth noting that this particular picture was taken while Dick, Ruby, and I were at a Dartmouth College conference on "Family Pictures."[37] Dick was there to show his photographs; I was there in a hybrid role as academic critic and wife/mother. I walked in and out of sessions pushing Ruby in a stroller, but also gave a panel presentation that was the earliest version of the present book.)

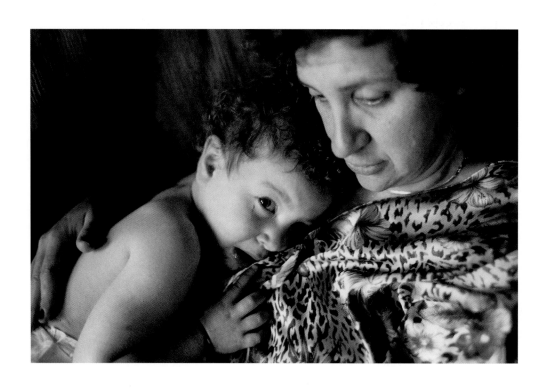

Ruby's right eye is the clear center of this photograph. The mark under her eye with its faint trail may suggest damage and tears but mostly underscores that sharp eye looking right at the camera. It is interesting to compare this photo to the one taken almost a year earlier at the lake. Ruby's scared, unhappy face and her direct engagement of the camera recall Max in the other picture. At the lake, Ruby was unaware of the camera just as she was unaware of the drama of parental attention; her physical position in my arms sufficed. Now she's old enough to know when I'm holding her but not fully with her. And so, not getting what she wants from me, she turns, like her brother before her, to Dick's camera.[38]

Whereas Max felt he had lost me to Ruby, Ruby here loses me to a faceless rival, one even harder to compete with—not another child or even another person, just something invisible compelling my attention. The irony is that in the picture by the lake, I was in fact as distant from Ruby as I am here. It wasn't just Max I wasn't looking at, it was Ruby too. Oblivious to both of them—even though they appear as if attached to either side of my body—in that picture I'm actually gazing out over the lake, I'm actually the mom who "looks miles away."

In my earlier reading of that photo, I looked only at the children—they, after all, face the camera. In that reading, the children have subjectivity, but I am the embodiment of the mother, merely the object of their rivalry. Further, that reading is amplified by its juxtaposition with the birthday party photo where I look very much like the symbolic mother, the devoted exemplum of family photography. Reading those two sibling rivalry photos together, I find the sort of alienated individual experience usually banished from the family album in the face of a child.

Which is where Bourdieu might expect it: in those least integrated by reason of their age or marital status, in the younger, single family members. But, like Bourdieu's "horrible picture," this photo of me in my nightgown holding Ruby shows us what might most frustrate our desire to see the symbolic family embodied. What poses the greatest threat to the "decent, reassuring" family album might be not the child's but the mother's secret individual experience.

In lieu of a conclusion to this chapter, let me offer one final photograph, which pairs the distracted mother with the hero of the first half of the chapter, the child making art.

Here is a scene from daily life, Max and me at the breakfast table. The familiar domesticity of kitchen, bathrobe, Kellogg's cereal, and disheveled hair all signal family, make us not just woman and child but mom and kid. But this is a family image likely to elicit disapproval from Bourdieu's exemplary subject. Our looks do not converge: Max and I both seem completely oblivious to each other, both of us lost in our own thoughts, in parallel concentration.

I'm serving food, a motherly enough activity, but I'm serving myself. (Not a children's cereal, Special K is in fact a cereal marketed to women.) Max, who doesn't have anything to eat, is coloring instead. With his art on the table in front of him, Max here recalls the photo where he's drawing angry. There too he was at a table meant for eating, but in front of him, rather than food, was his art.

A psychoanalytic reading of this photograph might say that Max has turned to art to compensate for the fact that his selfish mother isn't giving

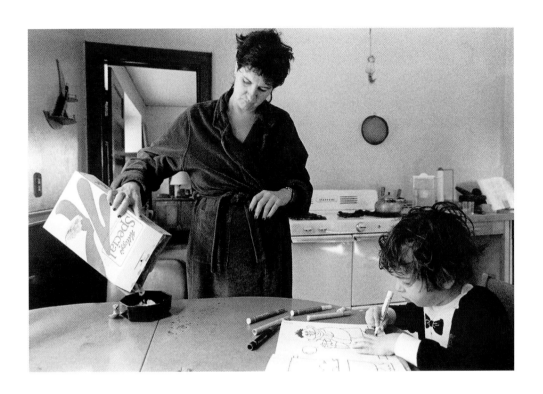

him nourishment. Although I'm confident that Max generally got fed, this psychoanalytic reading recalls Castel's conclusion to *Un Art moyen,* his idea of art as an imaginary compensation for real frustrations (and in psychoanalysis the archetypal frustration is imposed by the mother onto the son).

That psychoanalytic reading seemed to fit with Max as angry artist. But Max is not angry here. Here we can in fact see a different image of the artist, and a different relation between his art and his parents. Whereas in the photo of Max angry his art was placed between him and his parents, here his art is not between us: he is not sitting opposite me but rather over to the side.

While our looks may not converge, Max and I have the same expression; we look similar in this picture. I'd like to imagine that the selfish mother here and her child lost in concentration on his coloring are, in their parallel self-involvement, natural allies. Both are figures *in* the family who resist subordinating themselves to the group—separate, parallel selves trying to function as individuals within the family.

These two figures might both represent resistances to traditional family photography. They both also represent more homely, realistic alternatives to dominant ideals. Rather than the idealized selfless mother, we see here the literal mother, the one who might need to feed herself. Rather than the heroic image of the artist, solitary and at the furthest remove from daily life, we see here a humbler view of art, art as part of daily life.

While the heroic artist (modernist or romantic) has to be in opposition to the devoted mother, these two figures don't have to be at odds. The literal mother and the more "ordinary image of artistic creation" can live comfortably side by side.[39]

This is a picture of art in the family. Not an opposition between art and the family but a vision of peaceful coexistence. Perhaps "art" and "the family" are not the right terms for what we see here—both still lofty abstractions, too idealized. What we see here is not "art and the family" but, more literally, coloring and breakfast cereal side by side. And perhaps it is precisely the move from lofty abstraction to mundane incarnation that allows us to get beyond opposition.

The two figures in the picture coexist comfortably not only with each other but also with the camera. As the artist-father comes to the breakfast table to make pictures, he can in fact identify with both the figures here. Dick can identify with Max making art, but as a parent serving his own needs he can also identify with me. In pursuit of his art, Dick nonetheless coexists here peacefully with his family. Max and I pay no more attention to the camera than we do to each other. But we know it's there, just as we are aware of each other's presence. We feel free here in our kitchen to ignore each other and go about getting the various forms of sustenance we each might need.

This was 1990. Along with twenty-four other artists from around the world, Dick was photographing a day in his life for an art exhibit in Czechoslovakia.[40] That exhibit belongs to the same moment as MoMA's 1991 "Pleasures and Terrors of Domestic Comfort": a moment in which the world of art photography is no longer separate from the world of family photography, a moment unimaginable in the universe of Bourdieu's *Photography*. In this moment, we move beyond Bourdieu's fundamental opposition to another arrangement—not a dialectical synthesis but something we might call cohabitation.

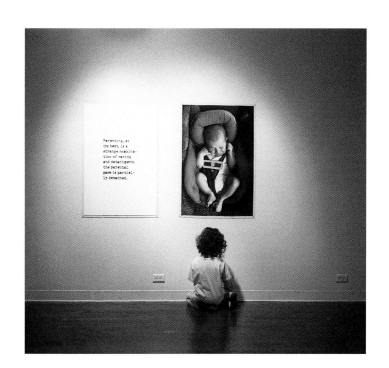

Notes

Living with His Camera

1 Susan Sontag, *On Photography* (New York: Dell, 1977), 81.

2 Ibid., 13–14.

3 Kathryn Harrison, *Exposure* (New York: Warner Books, 1993), 23–24.

1. Observations of a Photographed Mother

1 Roland Barthes, *Camera Lucida: Reflections on Photography*, trans. Richard Howard (New York: Hill and Wang, 1981), 10; further citations appear as parenthetical page references in the text.

2 The original French for this passage reads: "une image—mon image—va naître: va-t-on m'accoucher d'un individu antipathique ou d'un 'type bien'?" Roland Barthes, *La Chambre claire* (Paris: Gallimard Seuil, 1980), 25.

3 Jane Gallop, "The Prick of the Object," in *Thinking through the Body* (New York: Columbia University Press, 1988), 149–60.

4 *Thinking through the Body,* 8; the internal quotation is from my writing elsewhere in that book. The "opposition between philosophers and mothers" derives its terms from a reading of Sade earlier in that book's preface.

5 As I write here about my previous writing about this image, I'm having grammatical difficulty with person and tense. If I speak about what is going on in the image or the writ-

ing, I should use the present tense and the third person. But if I want to speak of what I did in that writing and that image, I should use the past tense and the first person. Neither choice feels right, but third person and present tense feel more comfortable.

The same dilemma arose in the introduction to the present book as I was writing about the cover photograph: "I find myself losing the pronoun of subjectivity, speaking of that body not as 'I' but as 'her.' Contemplating this body without a face, I find that it cannot speak; I can only speak about it."

6 *Camera Lucida,* 69, translation modified; *La chambre claire,* 107–9.

7 *La Chambre claire,* 107–9. The original French has the verb *observer,* an exact cognate of our English verb "observe," to match the later "observation" (in both languages). The English translator has obscured the resonance by translating the initial verb as "I studied."

8 If we take Barthes's mother as the book's *spectrum,* then we have another sense of why the *spectrum* is a specter. *Camera Lucida* was written shortly after Barthes's mother died. She is, at the moment he is writing, a ghost he is living with.

9 I am both puzzled and amused to note that I claim here to be both "offspring" and "mother." While my intellectual relation to Barthes is filial, I am trying to take up the position of his mother. An interesting oedipal twist, not unfamiliar to me: the daughter mothering the father; and not without its counterpart in *Camera Lucida,* where Barthes claims that at the end of her life his mother became his little girl (72).

10 Barthes's French word *moi* could also be given the more psychoanalytic translation "ego" (*La Chambre claire,* 26).

11 In the context of photography, it must be noted that the French word he uses, *léger,* unlike its English translation, does not mean the opposite of dark but only the opposite of heavy (*Camera Lucida,* 12; *La Chambre claire,* 27).

12 "Heavy," for example, is in this passage linked to "motionless" and the ideological; "light" to dispersion and the "zero degree."

13 This is, to be sure, a theme for Barthes as well. In his autobiography, he places this caption above a photograph of himself as a young boy: "Sudden mutation of the body: changing (or appearing to change) from slender to plump. Ever since, perpetual struggle with this

body to return it to its essential slenderness" (*Roland Barthes*, trans. Richard Howard [Berkeley: University of California Press, 1994], 30).

14 "Observations of a Mother," in Marianne Hirsch, ed., *The Familial Gaze* (Hanover, N.H.: University Press of New England, 1999), 67–84.

15 *Camera Lucida*, 68, translation modified; *La Chambre claire*, 108. The English translation puts "or Wife" in parentheses, whereas there are no parentheses in the French title.

16 Lynne Joyrich, various personal conversations.

17 *Camera Lucida*, 103; *La Chambre claire*, 161, translation modified.

18 Table of illustrations, *La Chambre claire*, 189.

19 I note that this family photograph bears certain structural resemblances to a photograph by Nadar in the first half of the book (52), and I wonder if Barthes chose the Nadar photo because of its resemblances to this family photo.

20 *Roland Barthes*, 177.

21 Roland Barthes, "The Death of the Author" in *Image, Music, Text*, trans. Stephen Heath (New York: Hill and Wang, 1977), 142–48.

22 Barthes's father is in fact "long since dead," having died before Barthes's first birthday.

23 *Roland Barthes* was his first attempt at that peculiar mix of subjectivity and theory that culminates in *Camera Lucida*.

24 *Roland Barthes par Roland Barthes* (Paris: Seuil, 1975), 25; translation, 21, translation modified.

25 "The mirror stage as formative of the function of the I as revealed in psychoanalytic experience," Jacques Lacan, "The Mirror Stage," in *Ecrits: A Selection*, trans. Alan Sheridan (New York: Norton, 1977), 7. Barthes's translator renders "tu es cela" as "that's you"; Lacan's translator gives us "thou art that." I have tried unsuccessfully to find the source of this quote in Lacan, which Barthes repeats.

26 In *Camera Lucida*, Barthes dislikes his image because it doesn't correspond with his "self." Here, in a book published five years earlier, we see his mother imposing the equation of self and image upon him. Of course, between the writing of the two books, Barthes's mother has died.

27 Lacan, "The Mirror Stage," 1.

28 And I have in fact seen it as that, not only in the preface to *Thinking through the Body* cited earlier, but also in the last piece I wrote before becoming a mother (an essay written just a few months before the photo here): "Reading the Mother Tongue," in *Around 1981* (New York: Routledge, 1992), 64.

29 *La Chambre claire*, 20; *Camera Lucida*, 8, translation modified.

30 Barthes names "psychoanalysis" as one of the "discourses" that make up his "critical language"; the other two named are semiology and sociology. The word "sociology" in this book turns out to point to Bourdieu's book on photography, a book that plays an important if largely hidden role in Barthes's encounter.

 Camera Lucida's complex relation to Bourdieu's *Photography* would make the object of a fascinating study (one beyond the scope of the present investigation). One could start on page 7: "Each time I would read something about Photography . . . an importunate voice (the voice of knowledge, of *scientia*) . . . adjured me, in a severe tone: '. . . What you are seeing here and what makes you suffer belongs to the category "Amateur Photographs," dealt with by a team of sociologists; nothing but the trace of a social protocol of integration, intended to reassert the Family, etc.'"

31 *La Chambre claire*, 112; *Camera Lucida*, 72, translation modified.

32 Barthes's lighthearted version of psychoanalysis and the split subject can be seen a decade earlier in *S/Z*, with its comic relation to castration.

33 Roland Barthes, *A Lover's Discourse: Fragments*, trans. Richard Howard (New York: Hill and Wang, 1978), originally published as *Fragments d'un discours amoureux* in 1977.

34 Every commentary on *Camera Lucida* (including my own in *Thinking through the Body*) focuses on the *studium* and the *punctum* and explicates this pair of terms as the book's major theoretical contribution. My reading here has chosen to focus instead on the other set of Latin terms Barthes introduces in this book, the generally ignored *operator*, *spectrum*, and *spectator*.

35 Worst of all to consider is not the beginning of the chapter as it now stands, but the first version of this chapter, the essay published in *The Familial Gaze*.

2. The Unhappy Woman and the Empty Chair

1 Susan Sontag, *On Photography* (New York: Dell, 1977), 13. Further citations appear as parenthetical page references in the text.

2 *Polka Happiness* (Philadelphia: Temple University Press, 1992).

3 These photos appear in *Bright Balkan Morning* (Middletown, Conn.: Wesleyan University Press, 2002).

4 See my *Feminist Accused of Sexual Harassment* (Durham: Duke University Press, 1997), and Margaret Talbot, "A Most Dangerous Method," *Lingua Franca*, Jan./Feb. 1994.

5 I owe the phrase "familial gaze" to Marianne Hirsch, see her *Family Frames: Photography, Narrative, and Postmemory* (Cambridge: Harvard University Press, 1997) and the volume she edited entitled *The Familial Gaze* (Hanover, N.H.: University Press of New England, 1999).

3. The Photographer's Desire

1 Kathryn Harrison, *Exposure* (New York: Warner Books, 1993). Further citations appear as parenthetical page references in the text.

2 Susan Sontag, *On Photography* (New York: Dell, 1977), 111.

3 Sontag, "Freak Show," *New York Review of Books*, November 15, 1973, 13–19. Diane Arbus, *Diane Arbus: An Aperture Monograph* (New York: Aperture, 1972).

4 Sontag, *On Photography*, 11–12.

5 Howard Coale, "The Photographer's Daughter," *New York Times Book Review*, March 14, 1993, 10.

6 Kathryn Harrison, *The Kiss: A Memoir* (New York: Random House, 1997), 54. Further citations appear as parenthetical references in the text.

7 Anne Higonnet, *Pictures of Innocence: The History and Crisis of Ideal Childhood* (New York: Thames and Hudson, 1998), 201. While this quotation comes from the last chapter of the book, "Knowing Childhood," Higonnet's elucidation of the slide from representation to reality in questions concerning child pornography appears in the previous chapter, "Photo-

graphs against the Law," as well as in her essay "Conclusions Based on Observation," in *The Familial Gaze*, ed. Marianne Hirsch (Hanover, N.H.: University Press of New England, 1999), 325–42.

8 Ibid., 206.

9 Ibid., 213.

10 *Frame/Work: A Journal of Images and Culture*, 3(1) (1989).

11 It did not in fact end up on the cover of the book because Dick was worried that Anna wouldn't like it. Instead I put another of Dick's photographs on the cover: a picture not of his own daughter but of his friend Charlie's daughter.

12 Higonnet, *Pictures of Innocence*, 109, 112.

13 Ibid., 121.

14 Carol Mavor, *Pleasures Taken: Performances of Sexuality and Loss in Victorian Photographs* (Durham: Duke University Press, 1995), 3, 5.

15 Higonnet, *Pictures of Innocence*, 87.

16 James R. Kincaid, *Child-Loving: The Erotic Child and Victorian Culture* (New York: Routledge, 1992), 68.

17 Ibid., 227–28.

18 J. M. Barrie, *Peter and Wendy* (New York: Charles Scribner's Sons, 1930), 37. In later editions the novel has been retitled *Peter Pan*. The title of the play developed from the novel is *Peter Pan, or The Boy Who Would Not Grow Up*. Quoted in Mavor, 6.

19 James R. Kincaid, *Erotic Innocence: The Culture of Child Molesting* (Durham: Duke University Press, 1998), 107. Whereas Kincaid's 1992 book was mainly about the Victorial period, *Erotic Innocence* is devoted primarily to the present and focuses in particular on the rejection of the darling child upon the onset of puberty. Kincaid's analysis also leads us to expect that the adorable child will be blonde.

20 Mavor, *Pleasures Taken*, 5–6. Quotation from Kincaid, *Child-Loving*, 278.

21 With its nexus of cross-dressing (Hook's dandyism, Peter usually played by a woman), *Peter Pan* in itself suggests that Neverland is not only the place where one doesn't have to grow up, but the place where gender is not irrevocable, not serious—as if growing up were coming under the laws of irrevocable gender (becoming a man). Our desire for the child may in

part be a longing for that place where gender is still for play, not for keeps.

22 Higonnet, *Pictures of Innocence*, 30.

23 In a sentence that could gloss *Exposure*'s description of Rogers's photograph, Higonnet writes: "If the child's body appeals sensually to adults because it is unconscious, then the deeply sleeping, possibly dead body will be very appealing" (*Pictures of Innocence*, 30).

4. Art in the Family

1 "Pleasures and Terrors of Domestic Comfort," Museum of Modern Art, New York, September 26 to December 31, 1991. A general account of the intersection of family and photography at the moment of the MoMA show can be found in "Look Who's Talking: Narratives of Family Representations," *Afterimage* 19 (7) (February 1992): 8–11.

2 Peter Galassi, *Pleasures and Terrors of Domestic Comfort* (New York: Museum of Modern Art, 1991), 9. Gowin was the teacher of Sally Mann, whose 1992 exhibit "Immediate Family" was constantly referenced in the reviews of the novel *Exposure*; Mann is certainly the best known of the photographers who make art of their families.

3 Jonathan Green, ed., *The Snapshot* (New York: Aperture, 1974). In this volume, Steven Halpern writes: "From its beginnings the snapshot has had two basic characteristics: a constant focus on family life and an informal, casual style . . . derived from the mobility of the hand-held camera" (66). In this Aperture book, Gowin's photos exemplify the first of the "two basic characteristics"; the other aspect of the snapshot can be exemplified by Nancy Rexroth's work in the volume, photos shot from 1970 to 1973 with a Diana, a $1.50 toy camera. Rexroth's work becomes exemplary of the state of photography in the 1970s in the title of Janet Malcolm's thoughtful consideration of photography in that decade, *Diana and Nikon* (Boston: Godine, 1980).

4 Galassi, *Pleasures and Terrors*, 9.

5 Pierre Bourdieu, *Photography: A Middle-Brow Art*, trans. Shaun Whiteside (Stanford: Stanford University Press, 1990), originally published as *Un Art moyen: Essai sur les usages sociaux de la photographie* (Paris: Minuit, 1965). Further citations of the English translation appear as parenthetical page references in the text.

6 Cited in *Photography*, 5; quote from preface of G. W. F. Hegel, *Principles of the Philosophy of Right*, trans. T. M. Knox (Oxford: Oxford University Press, 1942).

7 That this may be true in a broader sense of Bourdieu's sociological studies is suggested by the fact that his study of the educational system in France in the early 1960s was taken up by the 1968 student revolutionaries even though Bourdieu did not see the student revolution coming. Bourdieu described the contradictions in the educational system so well that he provided a template for the demands of the student revolutionaries. He thought, however, what he was describing was an unchanging structure, not a historical moment on the brink of crisis. The book on the contradictions in the French educational system is Pierre Bourdieu and Jean-Claude Passeron, *The Inheritors: French Students and Their Relation to Culture* (Chicago: University of Chicago Press, 1979), originally published in French in 1964. For an account of the volume's relation to the 1968 student revolution, see David Swartz, *Culture and Power: The Sociology of Pierre Bourdieu* (Chicago: University of Chicago Press, 1997).

8 *American Heritage Dictionary of the English Language* (New York: American Heritage, 1969), 21. Bourdieu, of course, wrote not the English "aesthete" but the French *esthète*. My French dictionary tells me that *esthète* is "often pejorative" (*Le Petit Robert*, 1987), 694.

9 *Oxford English Dictionary* (Oxford: Clarendon, 1989); *Oxford Dictionary of World Religions* (Oxford: Oxford University Press, 1997). Bourdieu's use of this word, along with a lot of other words connected to religion ("ritual," "cult"), no doubt stems from the fact that he is constructing his sociology of art on the model of Durkheim's sociology of religion.

10 This is a central and insistently problematic question for Bourdieu. In later works he will vigorously and polemically deny the existence of a "popular aesthetic," and say that in his 1965 book on photography he was mistaken in positing one. But even in *Photography*, the "popular aesthetics" has a complex mode of existence, what I am here calling "in quotation marks." For example, we read on page 85: "If sociology . . . places practices and works . . . like popular photography . . . under the general heading of aesthetics, it would be a sort of inverse ethnocentricity to see this as the expression of a 'popular aesthetic': in fact, the experiences corresponding to these practices have nothing to do with the pursuit of beauty in and for itself."

11 "In every way the opposite of a pure aesthetic, the popular 'aesthetic' . . . follows on logically from the social functions conferred upon photography" (80). It is interesting to note that Whiteside, the English translator, chose to put the second "aesthetic" in quotation marks, even though these marks are not in the original French (116).

12 Galassi refers to what he calls "Weston's late family pictures" (9), and illustrates this citation with a photograph of Cole and Dorothy Weston made in 1945.

13 Higonnet also goes further back into Weston's work than Galassi, discussing photos from 1925, from the very peak of his career (*Pictures of Innocence: The History and Crisis of Ideal Childhood* [New York: Thames and Hudson, 1998]).

14 Ibid., 133. Higonnet is quoting from Abigail Solomon-Godeau, "Winning the Game When the Rules Have Been Changed: Art Photography and Post-Modernism," *Exposure* 23 (1) (spring 1985): 6.

15 Higonnet, *Pictures of Innocence*, 115; quoting from Edward Weston, *The Daybooks of Edward Weston. Vol. 1: Mexico*, ed. Nancy Newhall (New York: Aperture, 1990), 147.

16 That Weston achieves in 1925 what Bourdieu can barely imagine forty years later may be attributable to the truly exceptional nature of the Neil photos or to the distortion produced by Bourdieu's exaggerated binary opposition or to both. Suffice it to say that Bourdieu was not thinking of Weston's Neil photos and that Weston's work is extraordinary enough in the history of art photography to qualify him in Galassi's account as the unique (and anachronistic) precursor to the post-1965 development of family art photography.

17 Higonnet, *Pictures of Innocence*, 134. Quote therein is from Nancy Newhall, "Edward Weston and the Nude," in *Edward Weston Omnibus: A Critical Anthology*, ed. Beaumont Newhall and Amy Conger (Salt Lake City: Gibbs M. Smith, 1984), 103. Newhall's verb "launched" would seem to allude to Shakespeare's "the face that launched a thousand ships," which refers to Helen and the power of Greek beauty, but in this case what beauty "launches" is not war but philosophy ("whole schools of thought"); i.e., the Western humanistic tradition.

18 Higonnet, *Pictures of Innocence*, 135, 137–39. Postmodernism is represented by Sherrie Levine's 1980 rephotographing of six of the Neil photos along with Douglas Crimp's essay, "The Photographic Activity of Postmodernism," *October* 15 (winter 1980): 91–101.

Higonnet's "perspective of the 1990s" is explicitly in the wake of Sally Mann's 1985 reinterpretation of one of Weston's Neil photos with a photograph of Mann's own son in her "Popsicle Drips."

19 Higonnet, *Pictures of Innocence*, 139; quoting from *The Daybooks of Edward Weston*, 118–19.

20 The resemblance between the official modernist Weston and the fictional Edgar Rogers suggests the derivation of the latter. Rogers is the modernist aesthetic embodied and placed in the family where he can feel nothing for his subject matter but aesthetic distance. At the beginning of the previous chapter I remarked that Edgar Rogers was in fact the photographer according to Sontag. I would add here that Sontag's view of the photographer is decidedly modernist, which then makes the photographer a monster in regard to any subject that *should* matter.

21 Higonnet, *Pictures of Innocence*, 138, 140.

22 Part of Higonnet's "perspective of the 1990s" includes Douglas Crimp's 1990 reading of the Neil photos in "the long-established codes of homo-eroticism," in "The Boys in My Bedroom," *Art in America* 78(2) (February 1990): 47–49.

23 *The Daybooks of Edward Weston,* 118–19; quoted in Higonnet, *Pictures of Innocence,* 139.

24 Although that particular adjective "lovely" bespeaks not the lexicon of the abstract modernist but something softer, more familiar and loving.

25 I owe my sense of the place of the buttocks as vulnerable flesh in our image of the child to James Kincaid, who has admirably delineated its contours—as object of the gaze, object of discipline, or object of fantasized caress—in both *Child-Loving* (New York: Routledge, 1992) and *Erotic Innocence* (Durham: Duke University Press, 1998).

26 This reflection could give a whole new resonance to Bourdieu's phrase "the ordinary image of artistic creation." We might then see Dick's photographs of children making art as capturing this "ordinary image of artistic creation."

27 *Un Art moyen,* 323. All passages from the French edition that do not appear in the English translation are my translations.

28 Although Bourdieu is listed as the author of *Un Art moyen,* the book in fact has several coauthors, who are part of his research team. Bourdieu wrote the introduction and part 1 (which lays out the theoretical overview); the various chapters of part 2 (more detailed eth-

nographic work on photographic subcultures) were written by Robert Castel, Dominique Schnapper, Luc Boltanski, Gérard Lagneau, and Jean-Claude Chamboredon. On occasions where I cite a passage by another writer, I will of course indicate it. All the passages from the book quoted to this point are from Bourdieu's introduction and part 1.

29 *Un Art moyen*, 287. Bourdieu's lifelong, complex relation to psychoanalysis would make the object of a fascinating study, one well beyond the scope of the present investigation. For example, Bourdieu at times refers to his own project as "social psychoanalysis" or says he is analyzing the "social unconscious."

30 The English edition likewise does not include two of the book's chapters: one on photojournalism by Luc Boltanski and one on advertising photography by Gérard Lagneau. The preface to the English language edition makes only this comment: "Some contributions to the original French edition were not directly concerned with the theme of photographic practice and were therefore excluded from the English language edition" (xi).

31 *Un Art moyen*, 355. In contrast to the conclusion, there is no indication of who actually wrote the appendix.

32 Bourdieu's lifelong, complex relation to Proust would make the object of a fascinating study, one well beyond the scope of the present investigation. For example, in a 1983 interview Bourdieu says: "At the risk of seeming arrogant . . . I think that . . . what Spitzer says about Proust's style is something I could say about my own writing" (interview with J. Heilbron and B. Maso, published in Dutch in *Sociologisch Tijdschift* 10(2) [October 1983]; reprinted in *In Other Words: Essays Toward a Reflexive Sociology,* trans. Matthew Adamson [Stanford: Stanford University Press, 1990], 51.)

33 *Un Art moyen*, 53.

34 I suspect that one of the functions of the present book is not unrelated to my circulating snaps of Max around the profession over a decade ago. Still trying to integrate my motherhood and my family life into my "group," this time I'm trying to do it more in the currency of that group, in professional rather than social currency.

35 Later in his career Bourdieu will state, more and more emphatically, that sociology must include a reflection on sociology, must move toward what he calls "Reflexive Sociology." See Pierre Bourdieu, *In Other Words: Essays Towards a Reflexive Sociology,* and Pierre

Bourdieu and Loïc Wacquant, *An Invitation to Reflexive Sociology* (Chicago: University of Chicago Press, 1992).

36 Bourdieu began in fact as anthropologist studying kinship structures through "genealogical science." See for example, Pierre Bourdieu, *Outline of a Theory of Practice,* trans. Richard Nice (Cambridge: Cambridge University Press, 1977), esp. 204 n. 54.

37 The conference "Family Pictures/Shapes of Memory" held in May 1996 was organized by Marianne Hirsch, along with a photographic exhibition entitled "The Familial Gaze." See the volume *The Familial Gaze,* ed. Marianne Hirsch (Hanover, N.H.: University Press of New England, 1999).

38 In both of these pictures as well as the birthday party shot, the unhappy child gazes from a single right eye. I think these single right eyes must connect to the fact that Dick puts his camera to his right eye. When the photo shows us a single, right-eyed gaze, we see a gaze that is in some way like the photographer's. It is worth noting that, in these three cases, it is the child suffering from insufficient attention who somehow "looks" like the photographer.

39 Or even be embodied in the same person, but that's a different story.

40 "One Day of Mine," Minigallery, University of Agriculture, Brno, Czechoslovakia, May 1, 1991.

Index

Angelitos, 111–12, 120

Arbus, Diane, 93

Around 1981, 183–84 n.28

Art: and the artist, 149, 150–54, 178–79; children's, 129, 149–53, 176–79; photography as, 15, 41, 98, 110, 130–79. *See also* Modernism

Barrie, J.M., 114–19, 146, 186–87 n.21

Barthes, Roland, 12–13, 17; *Camera Lucida* (*La Chambre Claire*), 12–13, 19–31, 35–36, 40, 44–47, 50, 51–54, 113, 181 n.2, 182 nn.7–11, 183 nn.15, 26; *A Lover's Discourse*, 53; *Roland Barthes*, 46–47, 49, 50, 182–83 n.13, 183 n.23; *spectrum*, 20, 27, 182 n.8, 184 n.34; *studium* and *punctum* 53, 184 n.34; *S/Z*, 184 n.32

Blau, Ruby, 82–85, 148–50, 160–66, 173–76

Bourdieu, Pierre, 17, 188 n.10, 191 nn.32, 35; artistic versus functional photography, 132–39, 141–44, 159–60, 162, 167–71, 179; "popular aesthetic," 136–37, 188 n.10, 189 n.11; *On Photography* (*Un Art Moyen*), 14–15, 132–36, 141, 147, 153–57, 159, 163–75, 178–79, 189 n.16, 190 nn. 26, 28, 190 n.28, 191 nn.29–31; social function of photography 155–60, 166–73 , 176, 179, 191

Camera: Leica, 8–10; as phallus, 6–7; as technology, 5, 8–9

Cameron, Julia Margaret, 110–13, 115, 119

Carroll, Lewis, 110–15, 119, 146

Cartier-Bresson, Henri, 9, 11

Castel, Robert, 153–54, 178

Children: as object of desire, 30, 93–129, 186–87 n.21; photography of, 14, 37–53, 77–153, 160–70, 173–79; the Romantic child, 120–29; as subject of desire, 99, 106–7, 116–18. See also *Angelitos*

Cohabitation, 1–8, 41–43, 57, 64–66, 77; as method, 12–18, 178–79

Crimp, Douglas, 189 n.18, 190 n.22

Daughter's Seduction, The, 107–8

Durkheim, Emile, 14

Family, the: archetypal, 44; cohesion of, 158–

79; hostility in, 41–61, 72–77, 152, 160–66; family roles, 1–10, 42–49, 64–66, 167–79; the family album, 157–163, 175; family resemblance, 39–42, 178; melodrama in, 61–62, 76–85; sibling rivalry in, 160–67, 175

Fathers: father-daughter relation, 11, 14, 95–109, 150; father-photographer, 11, 14, 41–44, 47–50, 91–103, 118, 139–43, 146–50, 160–62, 167, 179; as patriarch, 42–43, 95

Feminist Accused of Sexual Harrassment, 107

Freud, Sigmund, 27, 106

Galassi, Peter, 131–32, 139, 189 nn.12–13, 16

Gallop, Max, 24, 32–43, 47–50, 78–85, 88–89, 116–18, 122–29, 144–47, 150–54, 160–66, 168, 176–79

Gender: androgyny, 149, 186–87 n.21; roles, 2–8, 56–76; and division of domestic labor, 2–3, 59, 64–66, 69, 176–79; and division of photographic labor, 56–62, 167–76

Gowin, Emmet, 131–32, 139, 187 n.2–3

Harrison, Kathryn: *Exposure*, 8, 11, 14, 17, 91–101, 107–16, 120–21, 127, 129, 130, 139, 146, 181 n.3, 187 n.23, 190 n.20; *The Kiss*, 14, 17, 96–101, 107–8, 116, 120

Hegel, G.W.F., 133–34

Heterosexuality: and the couple, 55–77, 103–7; and domestic roles, 2–6, 10, 57–60

Higgonet, Anne: on family photography, 142–44; history of child photography, 100–101, 110–11, 114–15; and photographic modernism, 139–40; *Pictures of Innocence*, 100, 139,

185–86 n.7, 189 n.13; and the Romantic child, 120, 122, 187 n.23. See also *Angelitos*

Hirsch, Marianne, 185 n.5

Kertesz, André, 9

Kincaid, James: *Child-Loving*, 190 n.25; *Erotic Innocence*, 186 n.19, 190 n.25; photography of children, 114–16, 119–20

Lacan, Jacques, 46–51, 53, 183 n.25

Lartigue, Jacques-Henri, 87–88, 90

Living together. *See* Cohabitation

Love, 30–31, 35, 53, 85–86, 144–46, 162

Malcolm, Janet, 187 n.3

Mann, Sally, 101, 187 n.2

Marriage, 4–8, 11, 18. *See also* Cohabitation

Mavor, Carol, 113–14, 119–20, 122

Mind/body split, 23–26

Mirror stage, the. *See* Lacan, Jacques

Modernism, 140–43, 153, 178–79

Mothers: the maternal, 21–22, 31–34, 36, 40–51, 160–66, 173–75; the Mother, 20–23, 27, 30, 36–37, 47–51, 166–75, 178; mother-son relationship, 32–53, 176–79; as photographic subject, 20–54, 160–67, 171–79; and pregnancy, 28–30

Museum of Modern Art, 93, 108, 109, 130, 179

Nadar, Félix, 35, 183 n.19

Narcissism, 30, 31, 49, 76

Newhall, Nancy, 140–41, 144, 189 n.17

Nixon, Nicholas, 101

Oedipus complex, 31, 34–37, 42–45, 50, 106–7

Parental gaze, 84–86

Personal/professional. *See* Public/private split

Photography: as aggression, 7–8, 10, 139; artistic status of, 131–44, 159–60, 162, 167–71, 179, 188 n.10, 189 n.11; birthday, 78–81, 163–66; black and white versus color, 4, 129, 140, 168; of children, 14, 37–53, 77–153, 160–70, 173–79; and distance, 57–60, 152; ethnographic, 63–67, 88–90; feminist reading of, 42, 51, 54; and Greek sculpture, 140–41, 144–45, 147–50; history of, 110–14, 119–20, 131–34, 140–42; manifest and latent in, 100–108; Mexican, 111, 120; modernist, 139–43; as objectification, 27–31, 94, 98; psychoanalytic account of, 31, 34–37, 42–54, 106–8, 153–54, 176, 178, 184 n.30; the snapshot, 15, 131–32, 134, 141–42, 169, 187 n.3; social function of, 33–34, 135–38, 147, 155–79, 191 n.34, 154–60; sociological account of, 14–15, 132–44, 153–60, 167–69, 184 n.30, 188 n.10; temporal logic of, 2, 7, 59, 71–76, 85, 114–20; theater and, 4, 43–44, 153; tragic and comic interpretations of, 75–85, 90, 125, 163, 166; wedding, 4, 170–71

Photographer: amateur versus artist, 97–99, 133–34, 142, 183 n.30; desire of, 108, 114, 118–20, 129–50; detachment of, 16, 60, 70, 77, 80, 84–88, 92–95, 99; father-photographer, 11, 14, 41–44, 47–50, 91–103, 118, 139–43, 146–50, 160, 162, 167, 179; gender of, 2–3, 6–8, 11, 41–43, 50, 59–60, 166–73; relationship of, to photographed, 11, 13, 41–50, 57–129, 131, 138–44, 146–47, 150, 162, 179; as tourist, 16, 57, 63–67, 87–90, 93–94, 125–27

Pleasures and Terrors of Domestic Comfort, The. See Galassi, Peter

Pleasures Taken. See Mavor, Carol

Proust, Marcel, 158–59, 163

Psychoanalysis, 27, 31, 34–37, 42–54, 106–8, 153–54, 176, 178, 184 n.30

Public/private split, 17, 23, 33–34, 37–43, 69, 81, 168–69, 173

Rexroth, Nancy, 187 n.3

Rivera, Diego, 140, 143

Snapshot, The. See Gowin, Emmet

Sontag, Susan: on instrumental rationality, 57–59; *On Photography*, 2, 6–8, 13, 16–17, 57–58, 62–63, 87–88, 90–93, 181 n.1, 190 n.20; photographic distance, 57–60; photography as non-intervention, 70–73, 94; psychology of photographer, 88, 90, 93–94, 125–27; touristic model of photographer, 88, 90, 93–94, 125–27

Specter, 40, 45, 105–7, 116

Subjectivity: photographic, 20–31; divided, 21–31, 42, 45, 51–54, 84–88, 144–48, 173, 181–82 n.5

Suffering, 55–64, 66–86, 160–66, 192

Thinking Through the Body, 183 n.4, 183–84 n.28, 184 n.34

Weston, Edward, 139–44, 146–47, 189 nn.12–13, 16, 190 n.20

Wives, 3–8, 168–69, 173

Jane Gallop is Distinguished Professor of English and
Comparative Literature at the University of Wisconsin,
Milwaukee. She is the author of *Thinking through the Body*
(1988), *Feminist Accused of Sexual Harassment* (Duke
University Press, 1997), and *Anecdotal Theory* (Duke University
Press, 2002).

Dick Blau is a photographer and Professor of Film at the
University of Wisconsin, Milwaukee. He has published two
books of photographs: *Polka Happiness* (1992) and *Bright
Balkan Morning* (2002).

Library of Congress Cataloging-in-Publication Data
Gallop, Jane.
Living with his camera / Jane Gallop ; photography by
Dick Blau.
Includes index.
ISBN 0-8223-3102-0 (cloth : alk. paper)
1. Blau, Dick, 1943– 2. Gallop, Jane, 1952- 3. Family.
4. Photographers—United States—Biography. 5. Feminists
—United States—Biography. I. Blau, Dick, 1943–
II. Title.
TR140.B517G35 2003 306.8—dc21 2002152609